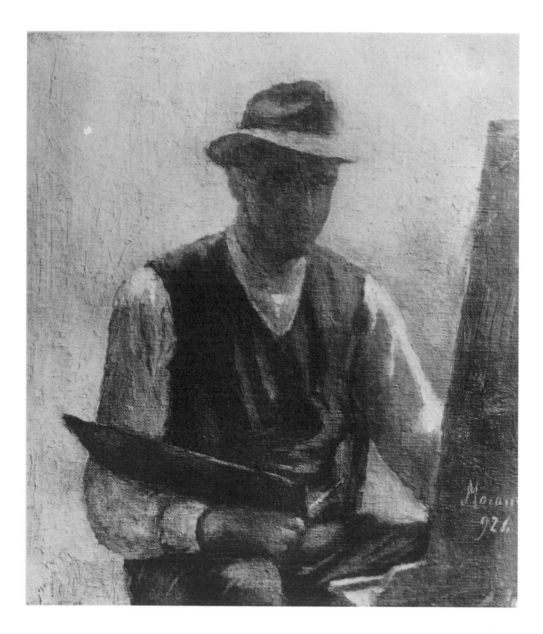

FABRIZIO D'AMICO

# MORANDI

CONTINENTS

The author and the publisher would like to
thank Gabriella Belli, Pier Giovanni Castagnoli,
Grazia Di Berardino, Massimo Di Carlo,
Laura Lorenzoni, Pier Paolo Pancotto and,
in particular, Marilena Pasquali.

PAGE 2

*Self-portait*, 1924, Milan, private collection.

EDITORIAL COORDINATOR
Paola Gallerani

TRANSLATION
Susan Wise

EDITING
Andrew Ellis

ICONOGRAPHIC RESEARCH
Alessandra Fracassi

CONSULTANT ART DIRECTOR
Orna Frommer-Dawson

GRAPHIC DESIGN
John and Orna Designs, London

LAYOUT
Cromographic srl, Milan

COLOUR SEPARATION
Eurofotolit, Cernusco sul Naviglio (Milan)

PRINTED OCTOBER 2004
by Conti Tipocolor, Calenzano (Florence)

# CONTENTS

The essay refers in abbreviated form to the following *catalogues raisonnés* of Morandi's work: L. Vitali, *Morandi. Dipinti* (Milan: Electa, 1977, 2 vols., 2nd ed. 1994; quoted here as "cat." followed by the catalogue number of the painting); *Morandi. L'opera grafica*, edited by M. Cordaro (Milan: Electa, 1990; quoted here as Cordaro, followed by the year and the number of the plate); *Morandi. Disegni*, edited by E. Tavoni and M. T. Morandi, with an essay by M. Pasquali (Milan: Electa, 1994); *Morandi. Acquerelli*, edited by M. Pasquali (Milan: Electa, 1991).

## THE FORMATIVE YEARS

Giorgio Morandi was born in Bologna and lived and died there. For a long time, a very long time, the Italian art world ignored him, despite his having participated in important group shows that had put him in touch with his contemporaries: first the Roman Secession, then the Futurists, and later the artists of the Pittura Metafisica ("metaphysical painting") movement transiting in Mario Broglio's art magazine, *Valori Plastici* ("plastic values"). Toward the mid-twenties when Carlo Carrà finally wrote a short piece on Morandi in *L'Ambrosiano*, he scarcely mentioned the artist's past involvements, though commented favourably on his latest landscapes and the "blessed solitude" of his research. This comment, coming from one of his oldest artist companions, gave a foretaste of the critical approach that would henceforth cling to Morandi's work, even in later years—in 1939 for instance, by now nearly fifty years old, Morandi won second prize in the third Roman Quadriennale (after Bruno Saetti!)—when his "case" had earned him attention and recognition, at least in Italy. A critical view that, in a positive light or not, took for granted his withdrawal in the ivory tower of his Bologna home, his seclusion from everything and refusal to enter any excessively open battle.

Though this image altered slightly over time, it was never entirely erased—this image of a Bologna entrenched in the shadow of its medieval towers and impervious to any form of modernism, became the symbol of Morandi's career. This was apparently confirmed by a life spent entirely within those walls, without the study trips abroad so essential for his colleagues; and also by the artist's reluctance to talk about himself and the self-sufficiency he felt that the language of painting should have. So while the bottles (forever dusty) in his studio and the landscapes of Grizzana (always desolate)— soon almost the only pretexts for his art—became convenient commonplaces for an often merely rhetorical interpretation. His solitary intercourse with a handful of illustrations of the works of a few great artist of the more or less recent past contained in books and magazines, became legendary. Over the years Morandi grew so used to this idea the world had about him that he finally yielded to it. Consequently, the

monographic study Francesco Arcangeli toiled upon in 1960 and 1961 in a great effort to rectify the situation, was received with reservations by the painter himself, for the very reason that had motivated the work, that is, Arcangeli's insistence on situating the artist more or less central to the art his day, and in fertile contact with other experiences going on around him (actually Arcangeli advanced far too many).

That image of isolation was not altogether implausible, and it was anyway positive enough to win Morandi faithful admirers and collectors, who sanctioned his success far more than the critics. Moreover, the image was not really revised until after the artist's death in 1964 as the enthralling echo of his unusual seclusion began to wane. An opposite critical tradition then began to emerge, intent on accurately weighing every single encounter, every possible influence, every journey that Morandi had made (he had in fact travelled to Florence, Venice, and Rome). This new approach dealt especially with the period of his formation and in particular the 1920s when Morandi was evidently by no means alone, nor yet wrapped up in himself, like a monad.

For confirmation we need only look at the first issues of Vitali's catalogue of Morandi's pictorial work. In sequence, it shows a *Woman's Portrait* (the portrait of his sister Dina), datable to 1912–13, in which one detects a certain primitivism not far removed from that expressed shortly before by André Derain in his "Gothic" period (Vitali, no. 3 of the *General Catalogue*: henceforth quoted as cat. 3); a 1913 *Landscape* steeped in a light still reminiscent of Impressionism (cat. 7); the Scheiwiller *Still Life* now ascribed to 1913 (and probably the end of that year; cat. 4) that links Morandi's work to that of his companions Osvaldo Licini, Giacomo Vespignani, and Severo Pozzati (cat. 12); several openly Cézannian experiments, like the Rollino *Landscape* (1913), or again the 1914 formerly Feroldi one (cats. 10, 16); the Cubist still lifes also pls. 2-4 from 1914; cats. 13, 18, 19); the *Bathers* perhaps Cézannian at first then clearly inspired by Soffici's as well as Derain's teaching (cats. 15, 21, 22).

All these paintings date to before 1915. Even if we can only reconstruct these trends through a very limited number of surviving examples (that is to say, those that Morandi deigned worth keeping), the extant works prove the extent and scope of his investigations, and the importance of his exchanges in those early years. They are more closely documented in the Chronology and the critical Bibliography at the end of this book. We need only point out here that the broad range of experiences influencing Morandi did not only, or mostly, relate to so-called "classical" or universally acclaimed art trends (moreover, at the time not even Cézanne was perceived as "classic" yet), but also to recognise (albeit controversial) sources within the livelier artistic debates taking place, like the one expressed in such the work of Ardengo Soffici, or exponents of the

extreme avant-garde such as the Futurists, or other artistic personalities who were not yet considered innovators, like Licini and his young Bolognese companions.

Consequently, Morandi's first steps were by no means regulated by fear or caution. Without going too far afield, he sought dialogue and involvement with his own generation, which lived, worked, and exhibited in Milan, Florence, and Rome. And yet at the very dawn of his career he created a magical, astonishingly personal form of painting, a type that is not easily explained, whose form is so accomplished that it almost cancels what came right after it. And after the next five years, so filled with curiosity, teeming with discoveries and confirmations, another type of painting in the same register responded to that first one (the Della Ragione *Landscape*, now in the Brera, cat. 25, 1915). As if to say, after seeking his bearings elsewhere, Morandi came back to where he started from. That crucial painting, the Vitali *Landscape* (cat. 2), dates pl. 1 to 1911. Cesare Brandi was the first to grasp its annunciatory significance, devoting to it words worth citing directly: "A small canvas in which the barely twenty year-old painter seized in just a few dense clotted marks the vision, not the least idyllic or welcoming, of a land whose horizon, suddenly swollen like a wave about to break, crashed against a sky enlarged by a boundless solitude, while a few crouching pock-marked shrubs beside blind huts offered the same mournful inaccessible distance." In the lividness permeating that land— its manner so radically detached from the natural context, the mute gloom gripping it, the time and space it seems to strive to measure with a huge compass, its essentialness always refusing to yield to the lures of the image—here Morandi is already truly accomplished. Working on the studio easel, he transcribes that slice of nature he would depict through the obvious filter of Cézanne (the pre-Impressionist Cézanne of 1869–70 that Zola so liked, and for which he prophesied a lasting critical failure: a period during which the Aix master, although attracted to the *plein air* technique, often composed landscapes of sheer invention); a Cézanne that Morandi saw and knew only through the black and white reproductions in Pica's book and from Soffici's articles in *La Voce* (see the Chronology), but perhaps for that very reason easier to recognise in the greatness of his early period. Cézanne, who, according to Brandi, was "the mainstay for his first formal research, his quotation being so intense and naïve that he marked a clear difference with respect to what was attempted" by other Italians, who also began with Cézanne and mostly ended up ensnared in the blue halo enveloping trees and mountains: namely, Boccioni and Marussig among others.

The year 1916's developments are complex and not easy to decipher, beginning perhaps with the Brera *Landscape*—warmer, with pink appearing here and there— which marks a more serene, mature return to the formal vein of the 1911 landscape. Yet it will be followed by works such as the formerly Longanesi *Flowers* (cat. 26), the

New York *Still Life* (cat. 27; Museum of Modern Art) and the two others with the
pl. 5 "spiralled" objects (cats. 28, 29). For that year, as regards iconography and form, the
valid reference to Henri Rousseau along with a reminiscence of a certain Italian
Quattrocento is always underscored: since "for Morandi, Rousseau's sincerity could
agree perfectly with what he considered Paolo Uccello's, and both of them echo the
same note of modernism to the painter's sensibility" (Castagnoli). Concurrently, as
Morandi himself pointed out, in this period Derain's name almost disappears. Yet it
returns in the New York *Still Life* with the quintessential Byzantine purity of the
volumes, reduced to bodiless silhouettes, juxtaposed on the plane. Their profiles cut
out against the brilliance of the background replicate Derain's 1912–13 inanimate
forms in the *Still life in front of the window* or the *Self-portrait with a pipe*. The
impression of life fluttering about once again right there in the pinks and greys of
the Frua *Still Life* is part of the mystery of that year ("a year of grace", according to
Arcangeli, and for Morandi certainly one of great change). For the first time the sense
of composition is firmly anchored in the highly calculated spacing of the four scaled
objects—but only in view of reciprocal relationships, without a single chiaroscuro
effect to back them up—in a reduced space at the centre of the picture plane.

Very little remains of his output from 1917, the afflicted year of his conscription and
a long illness; however, the *Cactus* (cat. 34) tells us the ulterior course of Morandi's
painting, that of 1918–19, had already begun. Morandi's unusual, quirky figure is
deeply carved out of the shadow, as if chiselled in stone and caught in an eternal,
frigid, unchanging moonlight: an optical trauma burning with truth and yet at the
same time icily estranged from life. Some say it anticipates his later Metaphysical
period: but not even through his singular brand of metaphysics would Morandi ever
quite capture the impression of mystery and foreboding a normal appearance of
nature assumed in this period.

And even when the Metaphysicists' token mannequin came to haunt the quiet
assemblies of these "most common objects", which De Chirico considered
constituent parts of his painting at the time, rarely (or never) would Morandi lend the
image such an alien, stifling air as that surrounding the *Cactus*, in which a mere folded
pl. 6 sheet of paper or a cut loaf of bread (in the Jucker *Still life* of 1918 for instance, cat. 40)
somehow mitigated the sense of the arcane looming over the picture plane. Then
pl. 7 when the following year the mannequin was broken, almost looking like a helmet
(cat. 43), and arranged with the bottle, the small piece of wood and the white cylinder,
spread out fan-like on the slightly tilted picture plane to give rhythm to the
measurable depth of the painting—then De Chirico but also Carrà were now behind
him forever, while a mood reminiscent of Paolo Uccello's *Battles* returned, stronger
than ever.

## THE TWENTIES: FROM "ANNUS MIRABILIS" TO STRAPAESE

But then came 1920, a crucial year in which we may presume Morandi's true course began, when he removed himself from all intercourse, and resumed the solitary condition in which his entire career would unfold. Was this isolation a conquest or a loss—perhaps even a mistake? In the future two contrasting views would divide scholars. At any event, the fact was that, after having lived among and shared with his peers, he found himself by parting from them; to paint in the confine of small spaces, which, to all intents and purposes, meant the room he used as a studio in Via Fondazza, and the garden in Grizzana. Here he spent his entire time looking, touching, arranging a few everyday things on the picture plane; leafing through the pictures of his meagre museum; listening to the few voices he trusted; meditating on form, self-absorbed, secretive, withdrawn from the world. So his person could not have been popular in the years between the two wars when the Fascist regime demanded something entirely different; and likewise, paradoxically, in the second postwar period, which for a long time resounded with opposite but not all that dissimilar rhetoric of commitment.

The year 1920 also witnessed Morandi's astonishing ability to explore different formal avenues: not at all incongruous with one another, each one seeming to spring from the one before, each one highly individual and yet without too deep a gap between them. Thus in his six 1920 versions of *Still life with the vase of flowers* that completed that year's production, we can at last sense Morandi's intention to work with all his might on "image-formulating" and on maintaining his "object-constituting" (Brandi), the pretext of a world he chose to represent. Such an idea was perhaps obvious for Morandi, but was later often misinterpreted: some critics would use this presumed fixity of the image to cast doubts on the man's spirit, suspecting him of being rather fastidious, while others, reacting to such an absurd supposition sought to explain his regular shift of direction with all kinds of reasons—all, however, tied once again to his relationship with the outside world—thereby failing to recognise these shifts as simply a concerted research into form, and exclusively the outcome of his changing reflections on form itself.

The year began with the so-called "round table" *Still Life* (cat. 51), and right after this pl. 8 came *Flowers* (cat. 56), consisting of a set of corollas arranged in an orderly triangular pl. 9 syntax without a single petal overlapping, in an intangibly pure white vase, anchored at the centre of the canvas by the perfect intersection of orthogonal lines that its axis forms with the plane of the table. Even more than *Flowers*, the "round table" *Still Life* complies with the rules of the *valori plastici*, marking the climax of Morandi's brief period spent in the orbit of the Rome-based magazine *Valori Plastici*, and coming

pl. 7   before the swing in the opposite direction denoted by the 1919 *Still Life* (cat. 43, formerly Broglio). There space is the real and only *genie* of the composition, and is explored and almost epitomised by the objects themselves—in evident deference to Paolo Uccello. Here objects, especially the fruit dish, take form like three-dimensional phonemes whose perfection is both asserted and undermined, or at least questioned, by the momentary interruption they cause in the purity of the spatial order, with that slight tilt to the right, slightly off-axis.

In April the Venice Biennale opened, and at last Morandi was able to see the large group of Cézannes in person. They left their mark on the *Still Life* (cat. 54; formerly Frua collection) and in part (along with a first intimation of Corot and Chardin that later would be so precious to him) on the other larger Bright *Still Life* (cat. 53). In the first it is especially the table and its solid weight in the depth carved out between foreground and background, even more than the quotation of the knife placed at an angle, and the apple, that reveal the new appeal that Cézanne had for Morandi. What the first anticipated was fully asserted in the second: compared to 1919, the less didactic, affirmative role of shadows. Tremulously brushing against the bodies, no longer seeming to prove their volumes but instead their presence, their weight and maybe even their affinity with life. So the *Still Life* (cat. 57; formerly Valdameri) must have come before both of these and maybe even before his trip to Venice, because of the reconstituting of the volumes' paradigmatic purity, whereas it is usually believed to come after the two former Frua and Bright ones, perhaps owing to that denser shadow out of which the objects loom.

The other Valdameri canvas (then Mazzotta; cat. 55) certainly came later, near the pl. 10  masterpiece that closed 1920, the Jesi *Still Life* (cat. 52). With it the new Morandi came forth, heralding the "dark, secret, trembling years [...] among his greatest and deepest", to use Arcangeli's words. The scholar considers 1921–24 the period during which Morandi discovered and immediately became aware of so much of himself: this sense of grasping things brimming with emotion and memory that issue from life to become painting; this composing *for* them and *with* them a space that is both a womb of existence and a highly studied formal gradient; the inner pace informing the volumes, alternating rarefaction and fullness, void and presence; this capacity of shadow to be at once a limpid hiatus and an anxious abyss. In short, Morandi's way of transforming painting into an inextricable sum of life and thought, confession and scrupulous vision. In the Jesi *Still Life* Morandi had only to invert the formerly painted silhouette of the clock and turn it into a dark, impervious wall; carve out of deep shadow the eroded body of the jar, draw closer, in the background, the two bottles, "long, raised over everything like two conspiring towers of old Bologna"; blur the table on the right with an unusually thick shadow: enough to give the old

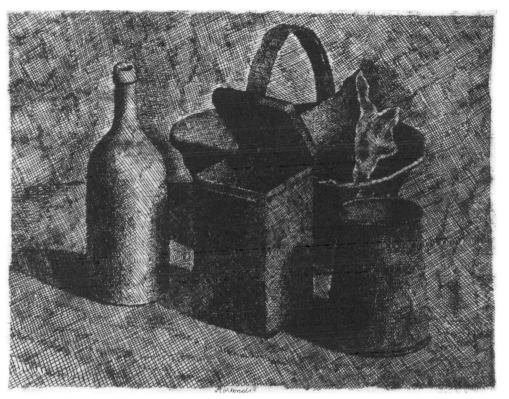

Fig. 1. *Large still life with a basket (small plate)*, 1921, Florence, Galleria degli Uffizi,
Gabinetto Disegni e Stampe, inv. 108799.

authority of "composing" (yet even here it underpins the image) a hoarse voice as
though broken by the echo of dark foreboding.

This phase practically began here, in the months that closed the *annus mirabilis* and
were followed up in the two canvases that introduce the year 1921 in the Vitali
catalogue (cats. 58, 59). The first, now in the Brera, assembles the objects, for the most pl. 11
part different (only the jug and jar reappear, repeating the reciprocal relationship they
had in the Jesi *Still Life*), on the same table, but as though exhausted by the zenithal
light: the rays play on them in three slight successive touches, lending rhythm to the
space. The second, again lacking in seduction and colour variations, seems assailed by
rust corroding the edges of the mutilated silhouettes of the objects, almost indistinct
in the dimness.

Both reveal strong affinities with the Jesi canvas. The only way to describe the inter-
action between his etching and painting from then on until 1934 (the chronological
hierarchies or precedences being uncertain), is to say that they were created "in the

presence" of his research in etching. This same year his printmaking reached a peak (see the three etchings numbered by Cordaro 1921.9, 10 and 11 [fig. 1]), as he pursued similar experiments in composition and tone. Yet at the time, the challenge of the medium caused Morandi to avoid involving it with the deeper enigmas of painting, exploring instead the opportunities it offered for arranging bodies in space in an inverted perspective, a formal device that Brandi had referred to as "positional colour" in Morandi's painting; here in the engravings that tonal structuring of colour was expressed in the intersections of the marks on the engraving plate, corresponding to the equivalent colour value.

While it is true that in the next few years Morandi would occasionally repeat textural experiments like the ones in the Bologna *Still Life* (cat. 59) (though often in smaller formats or very reduced size as a experiment or a challenge), nothing in the near future would match the intense dramatic concentration of 1920 and 1921. Conversely, just at the limit of the period indicated by Arcangeli as strongly consistent with the year 1924 (which for Morandi signalled another, quite different peak of quality), works of great and serene scope arose, founded on yet a further deviation from his permanent acquisition of the formal instrument of "tone". A series of masterpieces followed in quick succession: the three self-portraits, one of which (cat. 96) was sent to the 1926 Milanese Italian Novecento exhibition (and if one considers the company it must have been in, there can be little surprise in Morandi's seeking seclusion). The white and pink corollas in the Bologna *Flowers* (cat. 91). Then the *Garden in via* pl. 14 *Fondazza* (cat. 102), Morandi's last prewar landscape to be steeped in such an engrossing, silent light which with a very gradual lowering of tone slowly opens the road toward the background, toward that horizon that is nearly erased, toward what ought to be sky and yet is not (this is certainly Morandi's most Seurat-like painting, along with its twin print: where the occasion of nature is hardly more obvious and therefore it may have slightly preceded the painting). And last, the extraordinary pl. 13 *Flowers in a vase*, again in the Bologna museum (cat. 88): petals, stamens, meagre corollas—almost ghosts of a once fuller life—appearing at the brim of a vase made only of its water colour, contained with difficulty in its form by an almost trembling outline as later it will be in the drawings. It is no longer attached to the plane by the horizon as had been the case in the more self-assured time of the *valori plastici*. It is merely grazed by a slight shadow on the right: only almost as if to express that very narrow interval of space separating, like a vacuum, the vase and its flowers from the background that advances toward them. So that if "tone" for Morandi went beyond its fundamental acceptation and became "positional colour" able to set an object in its space without using shadows, without plasticity, without perspective frills, this was achieved for the first time in these *Flowers*: masters unheeded except by the few who could understand them, and among those, first of all Mario Mafai.

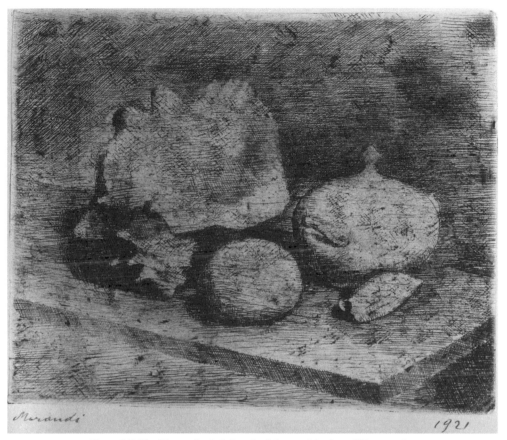

Fig. 2. *Still life with sugar bowl, shells and a fruit*, 1921, Mamiano di Traversetolo,
Fondazione Magnani Rocca, inv. 55 A.F. 91.

As Brandi wrote: "So we reached 1924 and one of the heights of his painting".
Arcangeli disagrees, particularly in light of the statement Brandi added ("At this time
he reached an agreement, a harmony with the world") that seems to merge this
extraordinary year for Morandi with the immediately subsequent ones, up to 1928 or
the first months of 1929, an entirely different period. Then Morandi, joining in the
Strapaese mood, appeared—at times with an astonishing, trusting abandon—to enjoy
the potential charms and graces of the world or, for once, of nature. Now especially
in the landscapes (a more and more frequent genre and for the first time capable of
reverberating decisive formal acquisitions on his still lifes) the light is so full and
festive, the density of atmosphere so warm and enveloping, that we can consider them
entirely new for Morandi.

In the course of 1925 several paintings already point in this new direction. The volume
of a house is firmly set amidst the vegetation (cat. 108), having completely dismissed

the suspended, stunned composure of his 1921 *Landscape* (which Morandi would
pl. 12  always remain fond of; cat. 66); or else a country lane extends so far toward the
horizon beyond the hastily sketched rows of trees that we might almost describe it as
Impressionist. But then 1927 is the year of a "Strapaese" Morandi: he confidently
gazed beyond the Apennines, recognising the one place (in Soffici, too, now close to
Maccari and his journal *Il Selvaggio*), in the midst of an Italy that largely ignored him,
where he had been given a home and an authentic human and critical solidarity
(Carrà, Lega, Longanesi, and Soffici himself were among the few to write about him
during these years). So here is the long series of warm sunny landscapes that seek a
diapason of light, disturb the shadows, discover a cracked, almost disorderly chromatic
pl. 15  texture (like this, in a private Roman collection, not catalogued by Vitali but men-
tioned in the supplement to the *catalogue raisonné* edited by Pasquali under number
1927.1). Impressions of saturation, of fullness as well as weariness tell of those parts of
the world where Cardarelli's "perpendicular sun" truly appears able to enervate any
other concern for form.

<div style="text-align:center">A YEAR OF CHANGE: 1929</div>

To some extent, the still life was able to match this mood. Several small canvases, like
the *Basket of fruit* that he gave Soffici (1927; cat. 118), or the same year a *Still Life*
(formerly in a private Milanese collection; cat. 119) share the "whispering" homely
everyday atmosphere of several coeval landscapes. Conversely a highly colourful
texture with occasionally a drowsy lingering chiaroscuro characterises other more
ambitious canvases of the same period like the 1928 formerly Jesi one (cat. 127). But
when Morandi took leave of Strapaese at the beginning of 1929, the *nature morte*
would lead him back to more familiar syntaxes. An admirable series would unfold that
year, and highly varied, considering the many directions they now explored. He gave
Longanesi the small oblong canvas with the objects prosaically set out on the table, all
at the same depth and almost shadowless: brown profiles against the bright ochre of
the background (cat. 151). He gave Soffici the more synthetic one with the clock,
the bottle and pan raised vertically on the large cloth of the same chromatic tone
(cat. 148). To Bartolini went the *Still Life* (later Jesi and now at the Brera; cat. 144) with
the objects bunched close to one another, with a background slashed by the close-
pl. 16  set brushstrokes. Then the other Brera one, also Jesi (cat. 143): an ample orderly
composition such as perhaps never chosen before to this extent, having a vast
assortment of dishes, decanters, bottles that form a crown right and left around the
light flickering in the middle, the real hub of this highly calculated arrangement,
scaled on each side—the epitome of the possession of "tone". The sole variation is the
painting's small (yet cogent) concavity: first hinted at in the slight curve of the table

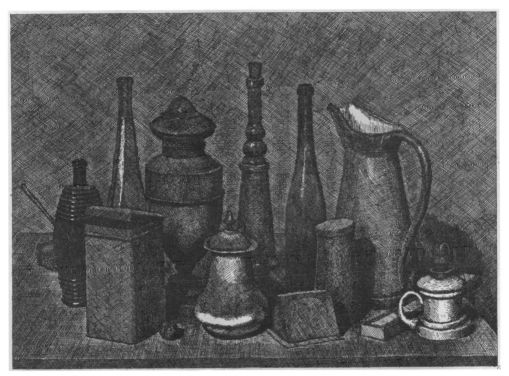

Fig. 3. *Large still life with the lamp on the right*, 1928, Florence, Galleria degli Uffizi, Gabinetto Disegni e Stampe, inv. 108827.

edge; then developed in the sequence of whites, which are lightly spotted with ochre and pink, lined up from left to right in the foreground; and last the light greys, slightly beyond, cordoned off by the sombre veil of the background. And to confirm the ineluctability of space that "positional colour" obtains with Morandi, we need but look at that thin thread of white rubbed against the bottle on the left, and observe the way this tiny device is sufficient to pull the object forward, altering its "normal" position in space—on the strength of that small touch of colour alone.

While the *Large still life with the lamp on the right* (Cordaro 1928.6 [fig. 3]) really dates to 1928 (instead of the seemingly more congruous 1929), then in this case we should assume the etching was done slightly before the painting. The controlled meticulousness of this plate, the complexity of its image, above all the extremely conscious use of "positional colour" (displayed in the etching by the variety of the hatching, its directions and texture that, as Brandi noted, match the slightest tonal variations of colour in the painting) are such that this plate, on which he worked at length and of which eight states before the final one are still extant, should be connected with the Jesi *Still Life*, also 1929. The *Large still life with the lamp on the right*

proves however that he may well have gone "beyond Strapaese" because of his further experiments in engraving. Here, compared to the Jesi picture, the intuition of space affected by the slight curve of the table and reflected in the arrangement of the objects is missing, as well as the very clear visual hierarchy presiding over them in that work; here they are scarcely grazed by a still natural light coming from the right. But then their distribution in a space teeming with presences is insured by the very density of the criss-crossed marks toward the background; or the marks' receptivity to light in the foreground. The plate, for the first time definitively, proves the gradient of luminosity belonging to each single object can no longer depend on the timbre of its local colour (accidental, like the material it may be composed of) but on its position and therefore its role in space.

For that same year 1929 there is the other plate, charged with a different formal conception, of the *Landscape on the Savena* (Cordaro 1929.5). Among the low fields and burnt vegetation, under the remote profile of the walls, slithers the snaky course of the river—almost overwhelming the canvas—untouched by point or acid: nothing but utterly white light. This is the first hint Morandi had of the suggestive power this speechless area, this sudden deafening silence dropped on the plate assumes in the economy of the image. Morandi realised that the whole sheet could be made to vibrate by it: mirrored in that untold portion of space, the entire warp of marks almost forcibly yields its referential obligation. Later such a broad exacting use of what we shall call his "absolute white" would be exceptional (see for instance the *Still life of vases on a table*, Cordaro 1921.5). But when it did happen (or even when, more often, large areas of quite intense lightness, barely inscribed by a light mark, would appear on the sheet; see for instance the *Still life with white objects on a dark background*, Cordaro 1931.3) Morandi would always draw from it this impression of reducing the image to its essence, almost an intentional impoverishment of its mimetic powers of reference to nature: thus demanding of his "white" to be less narrative and make the form throb.

A RIPE MATURITY

This formal intent that predominated over both painting and etching did not imply the disappearance of reality. For Morandi what it meant was that reality cannot be replicated in its familiar terms. All in all, the "dissolving attack on the object" that Brandi read during these years and Arcangeli substantially denied was just that. For Morandi it led to such different things as still lifes where the objects, scarcely recognisable, waver on the picture plane, tossed by a sudden gust of wind (cat. 164); or where they gather anxiously, flayed by swift daring brushstrokes (cat. 166); or again

in 1931, the ones where the very white objects soar and then suddenly, a bit further back, are unexpectedly steeped in shadow, wavering, slipping, suddenly huge, no longer willing to stay within the "genre" for which they were born, precisely the still life (cat. 169). Or else in the plate—to go back to this prolific year 1931—with the *Still life with drapery* (Cordaro 1931.1 [fig. 4]) where even Arcangeli could no longer make out "a few things on drapery" but instead "a condemned landscape of rocks or bones or human limbs".

Fig. 4. *Still life with drapery*, 1931, Bologna, Museo Morandi, inv. 233.

That extraordinary etched *Still Life* was as filled with randomness and dim with gloom, lit by piercing glimmers, as the 1932 Longhi *Landscape* (cat. 174) following pl. 17 close on would be sparing in presences and clamour, eroded, rough, and prostrate. Truly a capital work of these years and heralding times yet remote, the exacting war years and even Morandi's last period. In the Longhi painting he seems to have actually built his landscape "to subtract", so worn away is the texture of the colour, the few figures inhabiting it reduced to ghosts. Yet it is raised upon geometricising partitions that despite its rarefaction give it a semblance of fixity solidified by centuries and an inexorable sense of boundlessness. I have the feeling that in the ensuing years Morandi would often use the premises of this landscape as his point of departure, its abrupt reduction, for the first time so radical compared to his first great and altogether different landscape period when he was bound to the splinter Strapaese movement and the journal *Il Selvaggio*. He would return to the theme of the geometric skeleton to anchor the spatiality of the painting (for instance in the Turin *Landscape*, 1935, cat. 200, or again less openly in the one in a private Milanese collection, 1936, cat. 216); or else he would project its echo by the ghostly inclination of the forms (in the Boschi *Landscape* of the Musei Civici, Milan, also dated 1935, cat. 195, for instance).

Yet Morandi the printmaker's crowning period (which he would never surpass) came before, in 1934. In these two or three years, approximately between 1932 and 1934, he seems to have devoted all his energy to etching even more than painting. Besides already in the days of *Il Selvaggio*, and later through the Venice Biennales (where from 1928 to 1934 he was always invited for the black and white section) and the Chair in etching that the Academy awarded him for his "great renown" (without having to enter the usual competition), everything seemed to confirm Morandi as the country's

Fig. 5. *Large still life with fourteen objects*, 1934, Florence, Galleria degli Uffizi, Gabinetto Disegni e Stampe, inv. 108898.

greatest etcher—at least until 1934, when to everyone's surprise, Longhi hailed him as "one of the best living painters in Italy". Everybody seems to have "forgotten" he had been a painter for the past twenty years, even Carrà, who, in 1925, mentioned the remarkable "landscapes of the latest and most recent period" that reminded him of "the morning song of the lark" (but after Carrà, who had been his companion in another period, everyone else felt free to "forget").

The *Large dark still life* (Cordaro 1934.1; similar to the *Large still life with fourteen objects*, Cordaro 1934.2 [fig. 5]) dated 1934 is generally regarded as the "summing-up time" of the height of Morandi's etching activity. "Christened *nocturnal* but more aptly it could be said *tragic*" (Vitali), here Morandi retrieved the ancient language of etching and gave it a final formulation, making his own the ultimate stage of a paradigmatic course that he felt began at least with Rembrandt. The thick gloom enveloping and saturating the small space densely occupied by the objects, at first sight emerges as the one true pathos-ridden reality of the large sheet. Just as significant is the compressing of shadow over shadow, body over body in a narrow depth, leaving each one, after having eroded its plastic vanity, the very sure consistence of its own volume. Thus, as in a mitigated Donatellesque *stiacciato* (flattening), an anxious, lasting energy flows from that group of things into the scarce space. So it may well appear "nocturnal" and perhaps even "tragic". But only provided we place that sense of estranged separateness, of enveloping melancholy that is its most visible result, second to the limpid rule of form it seeks. That the deepest mainspring of the *Large dark still life* cannot and should not be only or pre-eminently identified with the sense of panic melancholy permeating it is corroborated by the long series of analogous compositions immediately preceding it (for instance see Cordaro numbers 1930.8 and 1933.1; or even, the same year, number 1934.2): entirely detached from any nocturnal or tragic sentimental supports they evince an increasing proximity with the achievements then entirely present in the 1934 plate. The comparison between the latter and the *Large still life with coffee-pot* (Cordaro 1933.1 [fig. 6]) is exemplary. The bright glowing composition is almost identical to that of the *Dark still life*; and particularly identical, even if carried to a slightly less accomplished degree of expression, is the way he pulls the image up close to the eye, denying our vision spaces of repose and escape. And the way he squeezes the volumes into a

minimal depth, entirely measured by the articulation of the objects, the closest of which almost exceeds the edge of the picture plane while, just a bit beyond it, the farthest are silhouetted against the background, thereby acquiring their identity. Last of all, the way he reduces the hatching and the extent of the acid corrosion, blurring the outlines of the individual objects so they are made to live an osmotic, shifting, intimately withdrawn self-absorbed life.

Fig. 6. *Large still life with coffee-pot*, 1933, Mamiano di Traversetolo, Fondazione Magnani Rocca, inv. 48 A.F. 99.

Vitali does not mention a single painting for 1933, and not more than ten for 1934, all landscapes, certainly executed during the summer Morandi spent at Grizzana. This is the surest proof that printmaking was his sole obsession at the time. But in 1935, when the great etching period came to a close, the *nature morte* returned, laden with new concepts that would flow consistently up to some time in 1937. Here there was a different way of heeding the richness and power of texture, its licitness in the image's economy; and he yielded to it, almost as though letting himself be led by its uneven, accelerated pace. This often went with an enlargement of the objects barely contained within the limits of the picture. At the same time his vehemence in placing them on the picture plane had not lessened, since every geometric evidence of space, its every Cartesian evidence, was rocked by the assault of this new crowding. And it is singular that this was precisely the time, in 1936– but certainly related to earlier things—of Renato Birolli's acute remark about Morandi in his *Taccuini* (Notebooks): "I don't know if his eye fears the slightest disturbance of the geometric arrangement. I tend to feel this stupendous distributive atony of the objects is inherent to his way of being and seeing". Thus it was on a new frontier that so many works of these brilliant hazardous two years arose, among which we shall point out but merely as an example the formerly Cardazzo *Still Life* (cat. 208), dated 1936.

But the next year would soon register a return to a more familiar composition. In that sense the Longhi *Still Life* (cat. 222) made headway and was already perfection. Its pl. 18 order was still complex but the volumes were more chaste and self-absorbed, identified by a colour that was both local (the browns, whites, blues were spelled out like transparent drops of a shadowless water) and again tonal. "Great bright light", Arcangeli wrote, and further on: "It is quite right to quote Piero della Francesca; and it may well be that the company of the scholarly artificer of Piero's fame in modern

time, Roberto Longhi, in those Bologna years left in Morandi's eye the chance in our day to strive on a smaller scale toward that sublime artist's symphonic harmony". On reading how cautiously this interpretation of the work was advanced (whereas instead it seems undisguised and almost obvious), we can but imagine a doubt on behalf of Morandi himself (expressed as usual to Arcangeli who was writing his biography) in feeling he had drawn close to a model that after realising he had considered it, he had then been fearful to confirm even to Longhi.

## THE 1939 ROME QUADRIENNALE AND THE WAR YEARS

1938 introduced a new period for the still life. Concurrently with returns to the "Piero della Francesca" manner that would last until 1941, the new phase carried Morandi through to the war years, and brought the wonderful series of landscapes ranging from then until 1944. Its first public showing, the very rich room the third Rome Quadriennale devoted to him, finally sanctioned his presence in Italian art of the time (still narrowly perceived but henceforth an ineluctable fact). A period—also extending beyond 1939—that was a great surprise at least for the very few who at the time knew and grasped the magnitude created by "tone" and the spatial layout it gave the image in Morandi's painting.

These were the years of a mark he would not repeat in the future and a different "divided and multiform" colour, almost possessing a timbre: a "display of pure, glossy tones like wet stones," Brandi wrote, soon after the Roman show that had somewhat reformed the image of the Morandi who had created the "positional colour" which the scholar himself had been the first to grasp and so admire. But Brandi could also admire this different Morandi, where the oranges and reds slipped in amidst the blues and whites giving the pictorial page a more relaxed rhythm formed by the clearly
pl. 19 identified bodies of the things (cat. 230). Composedly arranged on the plane—and often on a single level—paratactically side by side without commotion, without shadows. He indeed loved it, feeling the painter in this more relaxed phase had attained a "serenity that concludes an inner torment", a fullness no longer shaken by the tragedy that so often hovered over Morandi's life and painting.

A "serenity" that also permeates the landscapes at least up until 1941. Some like the
pl. 20 Giovanardi one with the white road that meanders down on the right (cat. 341) can occasionally even reflect a vague nineteenth-century mood; but unlike the ones that had seemed to appear by surprise in the twenties (from the *Landscape* that belonged to Bardi up to the 1927 one with the large poplar tree, cats. 68, 119), a firmer, drier, less narrative nineteenth century. This period for Morandi when the war broke out,

ravaged Europe and finally involved Italy was in turn grandiose or humble with a "wealth of alternatives already through foresight and choice, aware of every possibility of flexion and rendering", to quote Arcangeli. A time when Morandi, who, after the 1939 Rome Quadriennale, could at last count on a greater critical response and was understandably comforted by this new recognition (from Brandi, Longhi, Vitali, Raimondi, Ragghianti, and Gnudi) somewhat surprises us by his ability to maintain the autonomy of his work amid the surrounding turmoil.

In 1943 this was no longer true. At this time, bound to a cruel moment in his life—with the shelter at last sought in the Apennines where he was a close witness of one of the cruellest episodes of Nazi retaliation—in this year of grief, arose the brief period of the greatest, most extreme landscape Morandi ever created. Anticipated by some pieces in 1942 (cat. 392 for instance, now owned by the Banca d'Italia; or pl. 21 the other Fornaris collection one in Turin, cat. 404), the landscape now is so drily essential, its voice so broken as to surpass every other Italian example. Henceforth the genre is gone forever: gone from these eroded volumes, limp under the ridge of the hill with trees reduced to skeletal arms vainly waving in the still air (cat. 470); gone from the mass of wind-beaten buildings in the sun-burnt plain (cat. 461); pl. 22 from the broad expanses of earth, burnt geometrical portions lying side by side on the plane: all in a crescendo of bitter charmlessness; of swift, blurred, uneasy "handwriting"; of colour laid and scraped off the canvas. Until the acme of the *Snowscape* of the Museo Revoltella (cat. 481), a hallucinated vision between light and dark of a livid age-old hillside. Greys out of which the pink, the red barely ooze. And yet something reminds us here of the 1911 Vitali landscape and its Cézannism: but no pl. 1 longer with the trust—naive but complete—and the aura that had permeated that fervent quotation at the time.

## THE POSTWAR YEARS: NEW-FOUND SERENITY

The postwar years immediately brought significant responses. After the one-man show that Longhi presented, Morandi won the painting award at the 1948 Biennale, and that same year Petrucci mounted a retrospective of the artist's prints at the Calcografia in Rome. Morandi's work was then shown and appreciated in the United States for the first time. Marxist criticism did not lessen this new recognition although it brought Morandi grief since it deplored (to our amazement) his lack of social commitment and involvement "with the overall problems of his countrymen" (Trombadori). A period of serenity had now arrived for the painter, reflected in his work, ever more focused on the formal foundations of his painting. Yet now and later when questioned on the subject he would not fail to express his doubts regarding the

assimilation, assumed by some, of his research with that of the great tradition of international abstractionism (he would for instance always deny the occasionally simplistic comparison with Mondrian), just as he would continue to claim his acceptance of a reference to reality.

However from 1945 to 1956 Morandi's painting focused more than ever before on themes devoted exclusively to a slow variation in form, as though the swing of the pendulum that for a long time had given rhythm to its rising, oscillating between formal reasons and their opposite, those bound to life, had slowed down. Then a sort of monotony seemed to occasionally graze the images, gathered even more than before around just a few themes, almost flaunting how unassuming they were. They would often repeat, even years later, compositional intuitions explored and then temporarily set aside, or others that explicitly tended to "series" with the slightest variations in light or tone from one canvas to another. Actually, repetition, which was obvious within a greatly increased production, should be perceived as a final concentration on the values of pure painting that now prevailed. They ruled the image and no longer allowed themselves a way out (or no longer yielded to existentially significant critical interpretations). I believe this intent of Morandi's explains first of all the sense of equanimity that characterises so much of his production between the late forties and the mid-fifties, and then in the midst of this period the very notion of "series" as for instance it appeared in the ten 1952 canvases representing the *Still Life*
pls. 25, 26 with the small yellow cloth (cats. 826, 828).

Morandi may not have been aware that the "series"—ever since came into being with Monet—also had the knack of draining the subject of its moods, randomness, inquisitiveness and giving it back to its portrayer as a dried, exhausted pretext. He might well have shunned such a contrived intent. Yet even if not the main reason, certainly the "series" as the prime arena of "object-constituting" (Brandi) was no longer "suffered", as implied in the 1911 *Landscape*, but instead so ingrained and familiar that it cleared the field of the self, leaving room exclusively for "image-formulating", and Morandi was in full possession of this arena. We have expressed this assumption in the words of the critic Cesare Brandi, much beloved by Morandi, who, with all due respect, described the critic's language (in a page devoted to his own work) as "typically impervious, clogged with similitudes that complicate the flow of reasoning".

Aside from being his greatest achievement in the process of painting "series", the *Still Lifes* with the yellow cloth reflect several typical formulas of Morandi's painting of these years. First of all the new relationship between objects and space. It is usually clearly indicated, often divided in the three canonical rhythms: frame, picture plane

and background, and just as often so spacious around the things as to allow their neat, orderly gathering at the centre in a more or less tight composition. Then light, as often at the time, has a normal source on the picture plane, creating just a few shadows on the sides of the objects that often draw their special degree of estrangement from the world from this light situation, as if they had been briefly withdrawn from the flow of existence and almost set apart in a silent, stunned limbo of expectancy.

Of course these characters do not concern every still life of the period. Yet they form a kind of *basso continuo* over which sometimes the slight variations of the image play. One of the most relevant for instance regards the objects' support: in several compositions (especially between 1948 and 1949, that is, at the very beginning of a phase begun suddenly yet otherwise consistent) it is abruptly cut off on the right. The objects in the splendid Morat *Still Life* in Fribourg for instance (cat. 683) hover pl. 24 over the void, squeezed into a large family on the edge of the table supporting them. This creates a lofty, anxious image whose openly constructive intent, carried almost to the extreme of the optical challenge motivating this singular assembly, avoids having a dramatic tone.

In these same years we have the major series that Arcangeli called the "square-layout" still lifes. Here the objects, grasped in "a sort of rectangular fortress of things", tend to form all together a central "figure" created by the various modulations of the colour tones that qualify them, almost always and entirely without *chiaroscuro* variations pl. 27 (cat. 920), rather than by the forms of the single objects whose individual appearance almost disappears. They belong to 1953–54, and in these apparently modest works, far removed from flights of inspiration, coarse gesticulation, fantastic randomness or emotional involvement—in these patient humble works Morandi appeared for the first time so remote from the world that he seemed to be laying the foundations for his final period. So Arcangeli could already write about one of these canvases that "here while resting as usual on a real model (all it is indeed is just a few of his usual bottles and boxes, merely arranged 'a certain way') he even denies himself the pleasure of discovering details: this leads him to claim and repeat that *nothing is more abstract than the visible world*".

THE FINAL YEARS

The 1956 canvas of the Museo Morandi (cat. 1013) still recalls the geometry that had pl. 28 seized the still lifes "in a square layout", while anticipating a new period. The objects have so grown in size that the one on the right overlaps the edges of the image. Concurrently a more anxious "handwriting" appears once again in tracing the

tremulous outlines and in laying on the colour, almost thick in some places. Another series: there are about ten paintings, all from 1956, that make cubes of slightly different colours become the fulcrum of the image. Henceforth the project's rigour is gone, and the objects are interchangeable in number, form, arrangement (for instance, the pan often replaces the blue ampulla in the middle ground). In the square-layout still lifes Morandi, by repeating geometric forms, pursued above all that "longing for an abstract space" that Pallucchini saw at work in these years. Even if Morandi—already anticipating what was to come—seemed more tempted by the dissolution of the visible than by its modular construction.

It is no coincidence that this same year, out of the visual theme that Morandi had developed in the 1956 still lifes, witnessed a fecund period of watercolour that would last until the end of his life. Created after a long absence from this technique that Morandi, like Cézanne, grew fond of in his old age, the two sheets that begin the year in Marilena Pasquali's *catalogue raisonné* (nos. 1956.1, 1956.2 [fig. 7]) are actually studies, or more probably replicas, of the full composition in the Museo Morandi in Bologna. They are still a far cry from the perfection of the sublimely dissolving watercolour technique that would not begin until 1959, concurrently with his painting and drawing. First they raise the quivering ghosts of things; then they merely transcribe their chromatic imprint left on the retina by their eroded body, or by their close-knit consistency; then they shift the solids and the voids that their shadow imprinted on space. In the watercolours we can also observe how close Morandi's painting was to Rothko's—though bearing in mind an insuperable distance marked by the different scale sought by the two artists, which implies among other things an entirely different degree of immersion in colour and even its physical experience (Pasquali catalogue, no. 1959.35).

pl. 29

Arcangeli saw the watercolours as henceforth "verging on abstraction". But not those alone, nor was that their sole end. In 1959 when Morandi undertook the small "series" of the two identical bottles separated by a small dark object moved slightly backward and by a little blue or white vase, slightly toward the foreground (cat. 1138), he had indeed given up imitating nature, allowing the two bodies varied by ochre and pink to rise from the plane—almost straining against a ground line that looks responsible for supporting them—and cease to be bodies endowed with their own individual volumetry, becoming screens of nothing but light. But going even further, he may have renounced the one prestige his still lifes had yielded to in the past decades: a harsh and demanding or daringly complex composition—at times even precarious— but always highly judicious and proof itself of the work's purpose. Here, now, a sort of weariness of that so thoroughly possessed mastery seized him, his voice catching in his throat, as it were. This group, and all the other still lifes to come, became more and

pl. 30

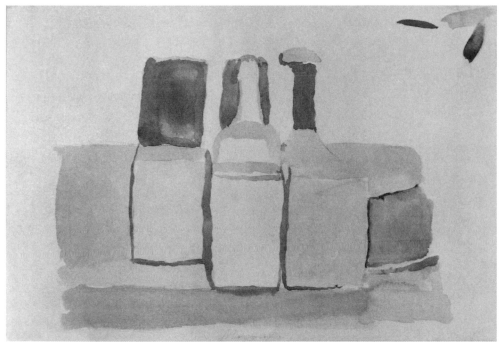

Fig. 7. *Still Life*, 1956, Milan, private collection.

more *sottovoce* and breathless: consigned to the canvas by a brush that did not heed to cover its comings and goings, nor to cancel the swift and frenetic "handwriting". They almost verged on the monochrome that went with their sought, intentional simplicity: whites veiled by the mist of greys, and occasionally a brief touch of a pink, a mauve, a dull blue.

Concurrently with his painted works, Morandi's drawing (from 1960 on, as Morat noted; but with hints in that direction as of 1956) reached a similar purity and essentialness. From now on it is utterly essential: often little more than a thread flowing unbroken over the page, seeking space, striving for light. Clambering insubstantial walls, inscribed by that rare reticent mark resounding on the barely grazed sheet. A tremulous thread struggling to contain things, half-outlined and half left gaping on the blank sheet. A thread that sometimes ravels to express a shadow: but a shadow of what now the weight of the body has vanished? The erosion of the world is achieved in the last drawings (and in many watercolours as well); the mark's freedom is complete: it acts dispersed, irresolute, on the traces of an unknown truth. A still life opens in spacious rhythms; a landscape inscribes wandering white ghosts, so that finally Morandi's two old manners seem to become a single one or even to switch roles. Is the *Still Life* (Tavoni no 1962.69r) where two objects—positive and negative, shadow and light—are placed together and separate as on the ridge of a hill actually just a still life?

There is yet time, the last months, for another period in landscape: complex, daring. Whereas the still life rushes into the embrace with nothingness, some landscapes like

pl. 31 the one in the Milanese private collection or the other one in the Bologna museum (both dated 1963, cats. 1289, 1332) are sunk in a plunging blind space that excludes even the horizon. Certainly the texture is so thin it looks scarified; the reverse of the brush on the peeled surface has removed colour rather than applying it; the image, raised vertically like an opaque screen, speaks only of the anxiety that constructed it. Yet in these landscapes we can make out the voluptuousness of a new, a last embrace of his beloved nature. And alongside these it is then surprising to find completely different landscapes, like the low one—the last Vitali listed in the catalogue of

pl. 32 paintings—of the Plaza collection in Caracas (cat. 1334), merely two white profiles, bare, affixed to the dull, sickly green of the hill.

LIST OF PLATES

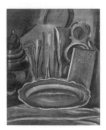

pl. 1. *Landscape*, 1911,
oil on cardboard mounted on
canvas, 37.5 x 52 cm, Milan,
Pinacoteca Nazionale di Brera
(Vitali no. 2).
Published in 1921 in *Valori Plastici*
(III, 4) this painting that once
belonged to Mario Broglio
(after having been shown at
Bologna in 1914) is the one that
abruptly ushers in Morandi's first
maturity: he finds an essential line
and a dry colour not found in other
landscapes of the same period.
Its source has been identified in
Cézanne (but only black and white
reproductions) discovered in Pica's
book on the French Impressionists
or, even more so, thought out
reading the articles Soffici
published in *La Voce* after 1909.
Exhibited in Germany in 1921.

pl. 2. *Still Life*, 1914,
oil on canvas, 73 x 64.5 cm,
Rovereto, Museo di Arte
Moderna e Contemporanea di
Trento e Rovereto, Giovanardi
collection (Vitali no. 13).
This must be one of the "glass still
lifes" Morandi presented in the
Hotel Baglioni show of March 1914.
He then sent one of them to
represent him in the 'Prima
Esposizione libera futurista'
(First Free Futurist Exhibition) of the
Galleria Sprovieri (Rome, April–May
1914), to which, with Licini and
Mario Bacchelli, he had asked
Boccioni to have them invited.
These still lifes reflect the painter's
brief proximity with Marinetti's
movement, which, doubtless
influenced by Soffici's similar
decision, Morandi did not want
to entirely reject.

pl. 3. *Still Life*, 1914,
oil on canvas, 102 x 40 cm, Paris,
Musée National d'Art Moderne,
Centre Georges Pompidou
(Vitali no. 18).
Another "glassware steeped
in gloom", as a review of the Hotel
Baglioni exhibition defined these
still lifes, with their splintered
surfaces and broken intersecting
spatial planes, in keeping with
a choice of images that here,
instead of referring to Futurism,
adopts Cubist models, familiar
to Morandi at the time through
Soffici once again.

pl. 4. *Still life with silver dish*,
1914, oil on canvas, 67 x 55 cm,
Rome, Galleria Nazionale d'Arte
Moderna (Vitali no. 19).
A new, quieter and more spacious
measure prevails in this still life,
painted at the same time as
Morandi's rare "Cubist" works but,
in the very choice of the chromatic
tone subtly shifting from pinks to
ochres, already rich with pauses,
sinuosity, and innovative
refinements.
Exhibited in the solo show Morandi
held at the 1939 Rome
Quadriennale. It belonged to Rino
Valdameri at the time.

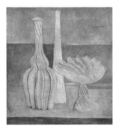

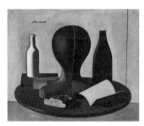

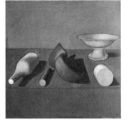

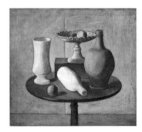

pl. 5. *Still Life*, 1916,
oil on canvas, 60 x 54 cm, Milan,
private collection (Vitali no. 28).
One of the few paintings of 1916,
all wonderfully serene, permeated
as they are with a full rosy light:
truly "a year of grace", the young
Morandi's first "perfect apogee"
as Arcangeli defined it. Of course
Henry Rousseau; and maybe again
the "primitive" Derain (we seem
to make out a recollection of him
in the bottle at centre: it has the
thin soaring quality of several of
the French master's self-portraits:
but now everything is sifted
through his precise determination
to "compose". The exact spatial
relations between the objects
already prove he was successful.
Exhibited in Germany in 1921.

pl. 6. *Still Life*, 1918,
oil on canvas, 47 x 58 cm,
Milan, Civico Museo d'Arte
Contemporanea (Vitali no. 40).
Published in *Valori Plastici* in 1919
(I, 11–12), the work marks
Morandi's first venture out of the
Metaphysical mood the painter
had dwelt in during the first
months of the year. The
mannequin is still there but it is
already surrounded by more
everyday objects with their plain
meaning. Indeed this "holy loaf
of bread, dark and cracked like
a secular rock" Giorgio de Chirico
described in a memorable page of
1922 fluctuates between familiarity
and dread.

pl. 7. *Still Life*, 1919,
oil on canvas, 59 x 60 cm, Milan,
Pinacoteca Nazionale di Brera
(Vitali no. 43).
This work as well (steeped in
references to the Italian
Quattrocento with memories of
Paolo Uccello hovering over the
fan-like arrangement of the
objects) like the preceding one
(pl. 6) was selected for the small
group of eleven paintings Morandi
sent to the 1948 Venice Biennale
in the exhibition devoted to
'Tre pittori italiani dal 1910 al 1920'
(Three Italian painters between
1910 and 1920) (Carrà, De Chirico,
Morandi), presented in the
catalogue by Francesco Arcangeli,
and which won Morandi the
painting award (doubtless thanks
to Roberto Longhi's advocacy).

pl. 8. *Still Life*, 1920,
oil on canvas, 60.5 x 66.5 cm,
Milan, Pinacoteca Nazionale di
Brera, Lamberto Vitali bequest
(Vitali no. 51).
An extraordinary accomplishment
of Morandi's aesthetic theory in the
"shadow" of Mario Broglio's *Valori
Plastici*, this work, where every line,
every body seems to conjure up
some bygone dream of perfection,
may also be one of the first ruled
by the sense of "composing":
carefully arranging the objects,
secluded and fully self-contained in
a space the eye can entirely try and
fathom. Shown in Berlin and the
exhibitions in Germany in 1921,
then in the 1922 'Fiorentina
Primaverile'.

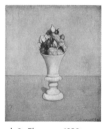

pl. 9. *Flowers*, 1920,
oil on canvas, 46 x 39 cm, Milan,
private collection (Vitali no. 56).
Unlike in any other of the
*Flowers* of this period and more
than in those to come, the
corollas—closed, compact—are
compressed, as if defining a figure
inspired by a geometric canon,
modulated within by the slow
shifting of chromatic tones.
A sovereign measure of grace that
reminds us of over a century of
French painting (from Chardin to
Corot, at least), but clenched in the
fist of a neat form and a pure light
that are still the legacy of Broglio's
movement and review. Shown in
New York in 1949 in the exhibition
'Twentieth-century Italian Art.'

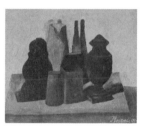

pl. 10. *Still Life*, 1920,
oil on canvas, 33 x 38 cm, Milan,
private collection (Vitali no. 52).
This is the "still life with seven
objects", sombre and dramatic,
that marks a clear break with the
other paintings of 1920, so it must
have come at the very end of that
year. Arcangeli wrote of it: "What
are these members of a mysterious
family assembled for? For defence,
for witchcraft? Everything is
disturbing: that raised lid; that
form on the right of the vase
hooded like a Tibetan; the profile
of the clock already so often
painted but now brown, dense,
crouching like someone kneeling;
even the two long bottles raised
over it all like conspiring towers
of old Bologna."

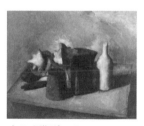

pl. 11. *Still Life*, 1921,
oil on canvas, 49 x 58 cm, Milan,
Pinacoteca Nazionale di Brera,
Emilio and Maria Jesi donation
(Vitali no. 58).
There is even a greater number of
objects in this still life. The eye falls
on them from above, squeezing
them within a crowded space,
retaining them on the slippery
picture plane, so unlike the stiff
assemblies of 1920. Now, "just a
year later, while the worn, familiar
forms of the objects return in a
flickering light, the paste of the
colour thickens, accumulates
in layers, nor does it avoid the
light graphism created by the
brushstroke" (Brandi) that
particularly stands out against the
unusually disturbed background

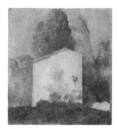

pl. 12. *Landscape*, 1921,
oil on canvas, 33 x 29 cm,
Bologna, Museo Morandi
(Vitali no. 66).
"A shadow called up out of
nowhere, suspended within
a serenely spectral hiatus,"
(Arcangeli): thus like an
apparition, this house
materialises—almost wavering
at the centre of the pictorial
page—without perspective frills
or openings, weightless or vacant.
One of Morandi's favourite
paintings since he recognised in
it the remote ancestor of so many
meditations on nature executed
even much later, it was shown
the first time in the 1939 Rome
Quadriennale.

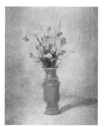

pl. 13. *Flowers*, 1924,
oil on canvas, 58 x 48 cm,
Bologna, Museo Morandi
(Vitali no. 88).
This work, mentioned in studies on
Morandi as never having been
exhibited by the painter (he did it
for his sister Dina, who kept it until
the donation that Morandi's sisters,
along with many other paintings,
made to the Bologna museum on
several occasions), was often and
correctly indicated as announcing
the series of Mario Mafai's *Flowers*:
it anticipates the veil of tremulous
life, dazzled with light that slips
space in between the stamens,
the corollas, around the vase.
A painting of *Flowers* we might
identify with this canvas since,
dated 1924, it is listed in the
catalogue as property of "D. M.",
and exhibited in the third Rome
Quadriennale in 1939.

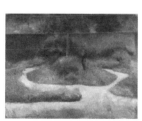

pl. 14. *Garden in via Fondazza*,
1924, oil on canvas, 33 x 42 cm,
Albinea (Reggio Emilia),
Ida Maramotti Lombardini
collection (Vitali no. 102).
One of the few landscapes of the
period, this small piece of nature
(like in Seurat not entirely involved
with reality: almost verging on
"abstraction"), used as a pretext to
verify the slow procession of light
over the ochre and the greens of
the daringly tonal chromatic
texture, is comparable to the
*Flowers* presently in Bologna
(pl. 13) or the *Self-portraits* of this
same 1924. At the same time as
the painting Morandi did an almost
similar etching, narratively slightly
richer (a row of vases are placed
close to the first terrace).

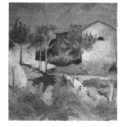

pl. 15. *Landscape*, 1927,
oil on canvas, 45 x 41.5 cm,
private collection (*Morandi.
Opere catalogate tra il 1985
e il 2000*, edited by M. Pasquali,
Bologna, Museo Morandi, 2000,
no. 1927.1).
With its rough texture and warm,
varied colour tone, this landscape
belongs to the years when
Morandi was close to the
Strapaese movement and its circle
(Maccari, Longanesi, Rosai, Achille
Lega, and again Soffici). Like other
works of this period, it verges on
a vibrant impression of nature
approached with neither qualms
nor fears in a moment of
"agreement, harmony with the
world" (Brandi). Along with the
other *Landscape* catalogued by
Vitali under no. 112 it belongs to
Antonio Baldini.

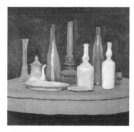

pl. 16. *Still Life*, 1929,
oil on canvas, 55 x 57 cm, Milan,
Pinacoteca Nazionale di Brera,
Emilio and Maria Jesi donation
(Vitali no. 143).
This is one of the large number
of still lifes dated to 1929, a time,
after several years in which the
landscape theme prevailed,
when Morandi went back to
concentrate on his objects
arranged on the picture plane.
In addition, now the stylistic
atmosphere of his painting is
extremely varied, the result of an
orderly, skilful "composing"—as
in the case of this canvas, where
the tone clearly paces out the
three successive planes of the
reduced depth of the picture—
or else of submission to an almost
overwrought texture (for instance
in the other Brera canvas,
Vitali no. 144).

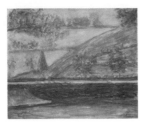

**pl. 17.** *Landscape*, 1932,
oil on canvas, 50.5 x 60.5 cm,
Florence, Fondazione Roberto
Longhi (Vitali no. 174).
In these years (that will go on up
to 1934) the frequency and high
quality of etching will somehow
prevail over painting. Not without
inspiring it with sudden perhaps
unforeseen intuitions. Such is the
case with this Longhi *Landscape*:
with its rough texture, the denials
on which it seems to be built, its
utter lack of solutions and grace,
it abruptly shrinks from the solar
encounter with nature that marked
his Strapaese years, anticipating
the formal solutions and emotional
disorders of the war time and the
last years. Shown in the 1939
Rome Quadriennale.

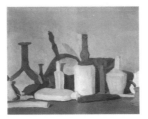

**pl. 18.** *Still Life*, 1937,
oil on canvas, 62 x 76 cm,
Florence, Fondazione Roberto
Longhi (Vitali no. 222).
In 1935 and even more so in 1936,
objects became huge on Morandi's
page, sometimes even filling the
entire space of the canvas from
foreground to background. There
is a new order here, evident in the
purity of the air surrounding the
objects, serenely juxtaposed and
without textural unevenness; while
colour—restricted to a few
overlapping tones—is contained
without shadows or chiaroscuro
within the limits conceded it by
an outline that might be tempted
by a geometrical notion.

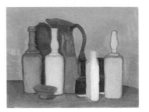

**pl. 19.** *Still Life*, 1938,
oil on canvas, 32 x 42 cm, Milan,
private collection (Vitali no. 230)
This is one of the recent still lifes
around which Morandi organised
his "solo show" in the 1939 Rome
Quadriennale (presenting with
them oil paintings from 1921 on,
along with several drawings and
watercolours dated up to 1934,
thus omitting his early work and
the period connected with Pittura
Metafisica). Among the 1938 still
lifes that finally drew the attention
of a certain number of critics, here
the bright accents that clash with
the overall tonal notion we have
of his painting are unusual and
will never again be repeated to
this degree.

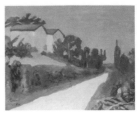

**pl. 20.** *Landscape (The White
Road)*, 1941, oil on canvas,
42 x 52.5 cm, Rovereto, Museo
di Arte Moderna e
Contemporanea di Trento e
Rovereto, Giovanardi collection
(Vitali no. 341).
This is one of the 1941 landscapes,
still amazingly serene for those
already difficult days. It seems to
strive to forget the geometrising
abbreviations of the natural form
and the rough surfaces that had
involved several landscapes of
the previous months and years:
as though seeking a refuge—in
the still safe exile of Grizzana—
from the upheavals of the war.
The outcome is paintings where,
as in this Giovanardi one, a serene
nature unfolds before the eye:
maybe a final reminiscence of
the early Italian Corot.

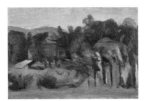

**pl. 21.** *Landscape*, 1942,
oil on canvas, 36 x 53 cm, Rome,
Banca d'Italia (Vitali no. 392).
One of the great landscapes that
will occupy the years from 1942
to 1944 (the Giovanardi *Landscape*
now at Rovereto pl. 22, has the
same mood) where the brush
seems to scrape the canvas with
an eroded material, anxiously
inscribing its broken, jerky paths
until the tortured colour, the
dazzling lights and the troubled
spatiality that precariously sustains
them finally confess Morandi's
grief—transfigured—over the times
he is experiencing and enduring
(jailed, although briefly, by the
Fascists, he would seek shelter at
Grizzana where he was to stay until
the summer of 1944, at the end of
which he witnessed the last of Nazi
retaliation, with the massacre of
civilians near Marzabotto).

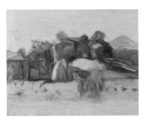

**pl. 22.** *Landscape*, 1943,
oil on canvas, 42 x 52.5 cm,
Rovereto, Museo di Arte
Moderna e Contemporanea di
Trento e Rovereto, Giovanardi
collection (Vitali no. 461).
The process Morandi is ripening
and we might almost define as
exhausting nature has truly reached
the verge of visual collapse.
Henceforth, mimesis is gone:
the white, light, extremely swift
graphism seems to trace mere
vapours, breaths, evanescences.
And in the famous lines Roberto
Longhi wrote on his painter friend
in 1966 (in the catalogue of the
Venice Biennale that paid the first
tribute to him after his death),
the exceptional character of these
landscapes is perfectly expressed:
"I saw him reach the acme of his
1943 landscapes, perhaps his
greatest achievement".

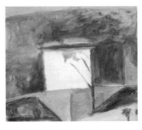

**pl. 23.** *Landscape*, 1943,
oil on canvas, 32.8 x 38 cm,
Bologna, Museo Morandi
(Vitali no. 471).
Bare, utterly simple and still, the
white rectangle of the windowless
house set right in the middle of the
larger rectangle of the canvas and
surrounded by other parts also
obeying a geometric canon, speaks
of another kind of form sought by
Morandi's landscape in the same
months as the preceding canvases.
Referring to a similar landscape,
Arcangeli mentioned "the
immense, transparent light,
the spare execution, made out
of nothing" and the rare traces
of trees, "hints of an ultimate,
fleeting life": all of them predicting
the other great period of Morandi's
landscapes in his last years.

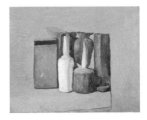

**pl. 24.** *Still Life*, 1949,
oil on canvas, 36.5 x 45.5 cm,
private collection
(Vitali no. 683).
This belongs to a small series of still
lifes in which the picture plane is
suddenly broken off on the right:
at times the objects crowded on
the edge look about to fall off.
Maybe for the first time a flaw
appears in the sense of lucid
"composing" that characterises
the great period of Morandi's still
lifes, as will subsequently occur
from time to time in his approach
to the theme. Conversely the more
dramatic, daring aspect of these
assemblies of objects, no longer
neatly displayed but almost
symbiotic, is heightened.

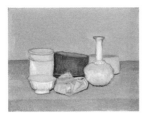

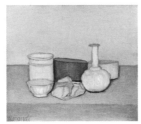

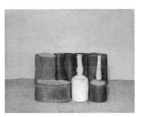

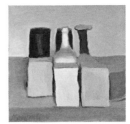

pl. 25. *Still Life*, 1952,
oil on canvas, 35.8 x 45.8 cm,
private collection
(Vitali no. 826).
It is one of the ten still lifes
that belong to Morandi's
iconographically most coherent
series, called "with the yellow
cloth", the single new element in
the group of its objects. The series
astonished many by its obviously
programmatic approach. Morandi
makes the viewpoint from which
the objects are seen and the source
of light identical, while he slightly
varies formats and colours.
Doubtless the repetition of a same
theme pursued to this degree is
bewildering and creates a distance
from the obviousness of the object
represented, while it emphasises
the formal values of the painting.

pl. 26. *Still Life*, 1952,
oil on canvas, 40,5 x 46 cm,
Milan, Mattioli Rossi collection
(Vitali no. 828).
Luigi Magnani recalls how
Morandi, imagining Magnani's
questions to himself in front of
one of the artist's series, replied:
"Look, even if I had a second
life I couldn't exhaust the
possibilities of this theme. [...]
So I understood", Magnani
continues, "the strict rhythmic,
formal exigency that rules his
painting and justifies every single
variation on the theme, every
slightest nuance of colour and
light, in order to return step by
step to the original idea and attain
the perfection he is seeking."

pl. 27. *Still Life*, 1954,
oil on canvas, 35 x 45 cm,
private collection
(Vitali no. 920).
This is one of the "square-layout
still lifes"—its image fits in a
rectangle (eventually imperfect)
containing and compressing all
the objects—Morandi worked on
between 1953 and 1955 and that
were described and commented
by Arcangeli. a sort of rectangular
fortalice of things" inside which
the objects "are nothing but
a sentiment so immersed in the
'sentiment of painting' that it
is no longer a sentiment in its
existential acceptation, but instead
the very suspension of that very
'existential' which had been so
fundamental for Morandi in
bygone years."

pl. 28. *Still Life*, 1956,
oil on canvas, 35.5 x 35 cm,
Bologna, Museo Morandi
(Vitali no. 1013).
New forms of freedom loom
on Morandi's horizon as he
considers his objects visual
"pretexts", in Longhi's sense,
rather than fragments of reality
for him to fathom in their
existential implications. "Nothing
is more abstract than the visible
world", he said. These objects,
turned into pure screens of
colour, lit frontally and therefore
almost devoid of the recesses
of shadow, already weary of
the balanced composition's
perfection that had been theirs,
are here to prove it.

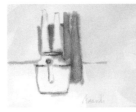

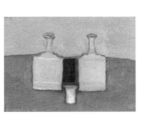

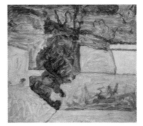

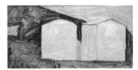

pl. 29. *Still Life*, 1962,
watercolour on paper,
21 x 31 cm, Bologna, Museo
Morandi (Pasquali no. 1962.4)
The great period of Morandi's
watercolours develops in his last
years. Occasionally tried out in his
youth, watercolour is used
frequently after 1956, but it is not
until 1958–59 that Morandi turns
to it in his striving to reduce the
image to its essentials that will
lead him to the verge of
abstraction. Often, as in this case,
full and empty exchange roles
(the definition of full being left
to the white of the paper),
creating on the page a phantasmal
rhythm, alternating presences
and absences.

pl. 30. *Still Life*, 1959,
oil on canvas, 25 x 35 cm, private
collection (Vitali no. 1138).
The extreme simplification of
nature as referent is common in
Morandi's last period. Concurrently
there are more exceptions to his
spatial rule. Here, in this *Still Life*
where there are no shadows
contributing to properly arrange
the objects in depth, the rhythm
starts on the left, with the bottle
leaning slightly toward the median
axis of the composition and with
the arbitrary horizon (constituted
by the colour of the picture plane)
rising almost imperceptibly to the
top of the bottle as if enveloping
it and pulling it toward the centre.

pl. 31. *Landscape*, 1963,
oil on canvas, 40 x 45 cm,
Bologna, Museo Morandi
(Vitali no. 1332).
This full, anxious painting is an
extreme swing of the pendulum
that gives rhythm to Morandi's last
contemplation of the landscape of
Grizzana: the other, opposite one
consisting of the firm bareness of
landscapes like the former Caracas
one (pl. 32). Here the absent
horizon compresses the mountain
shard, the vegetation, the profiles
of the houses, all inscribed with
a rough texture, anxiously added
and subtracted, on the plane of
a surface felt to be the sole abode
of painting.

pl. 32. *Landscape*, 1963,
oil on canvas, 25 x 50 cm,
Turin, private collection
(Vitali no. 1334).
Two houses, weightless and
without foundations, shadows
or windows, anchored by the
bare hillside looming over them,
are the sole presences in this
landscape. Does Morandi
perhaps, in this very last of his
paintings, recall the equally bare
and ambiguously suspended
presence of the house of 1921
(pl. 12)? Certainly a great deal
of his past filters through this
last sieve, where the signature
he writes on the left in large
letters is like a last gasp of life
breathed in the non existence
he now beholds.

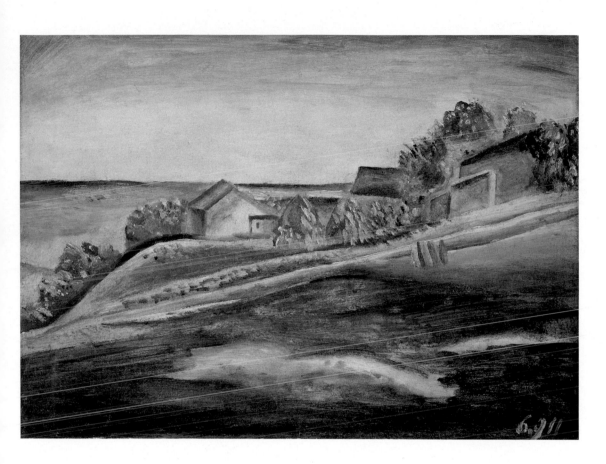

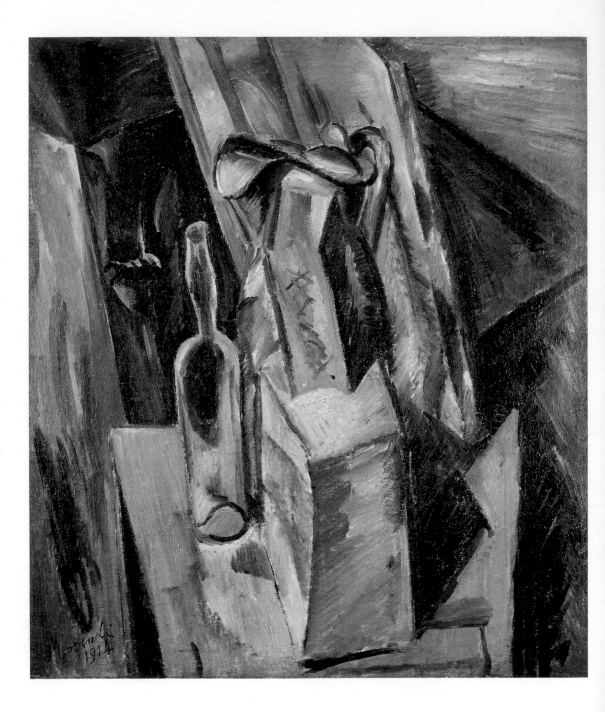

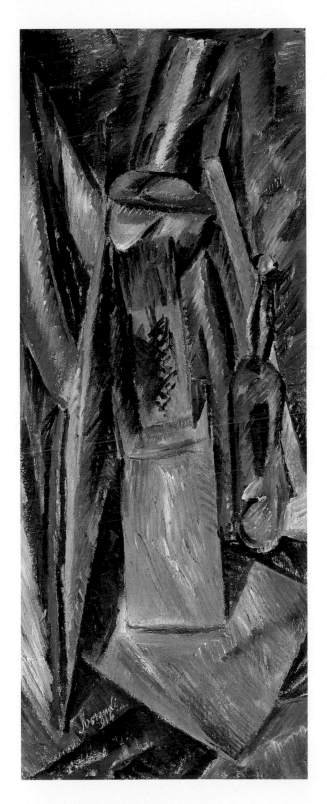

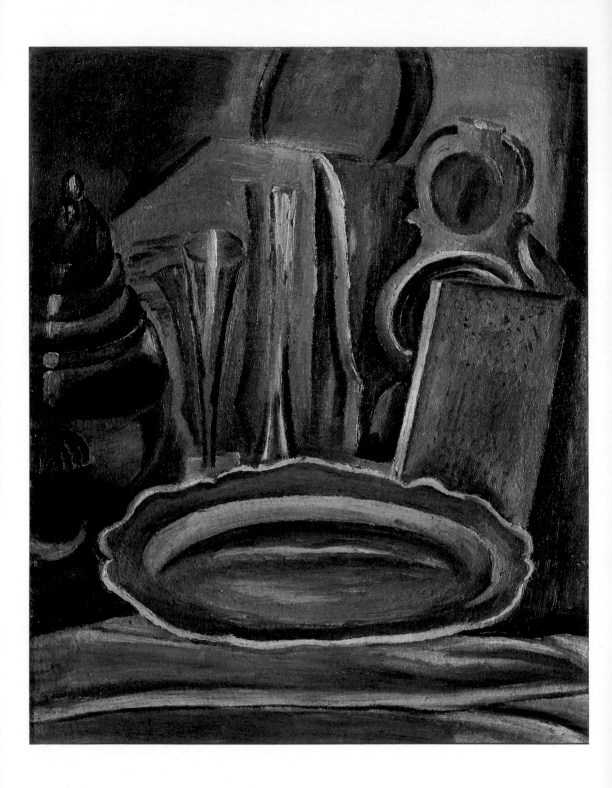

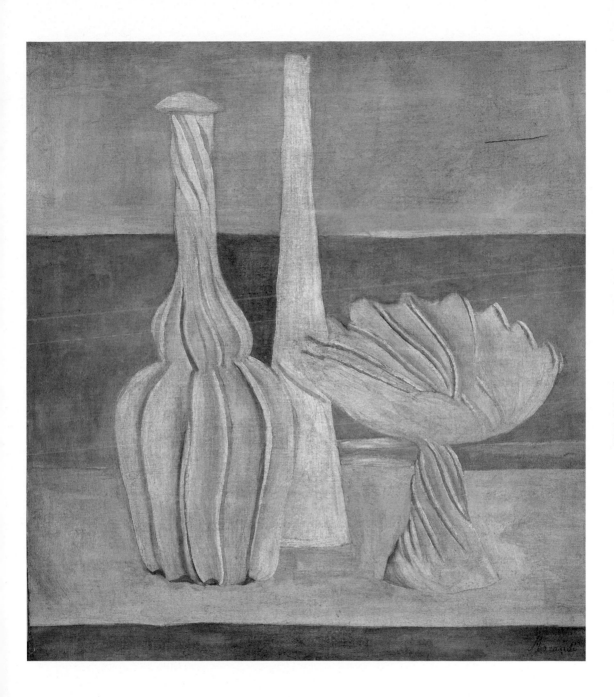

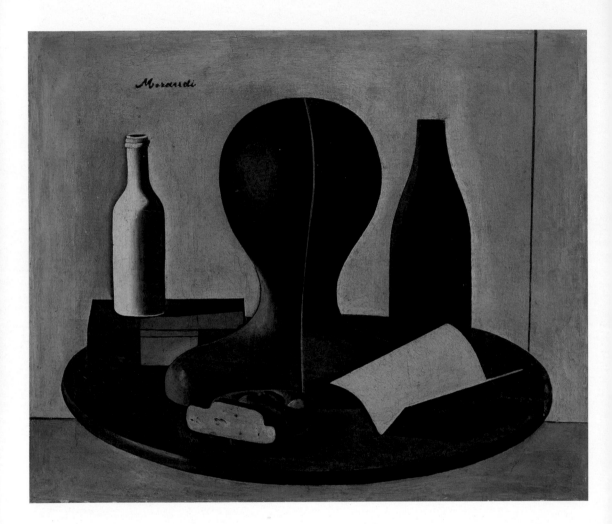

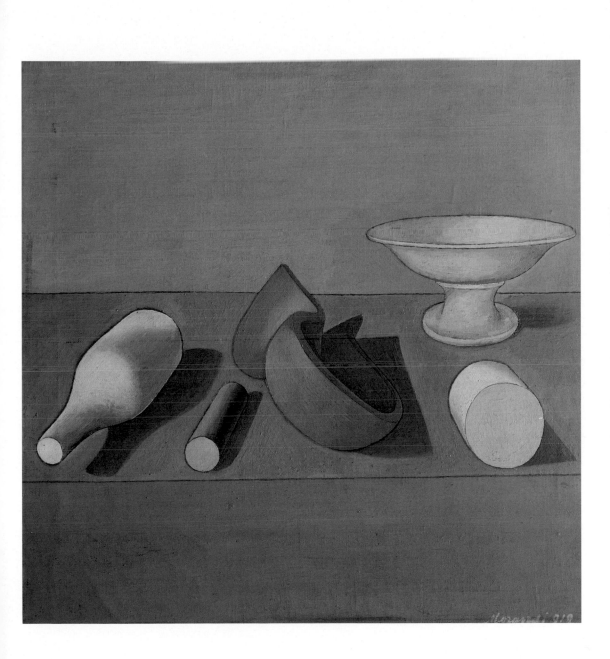

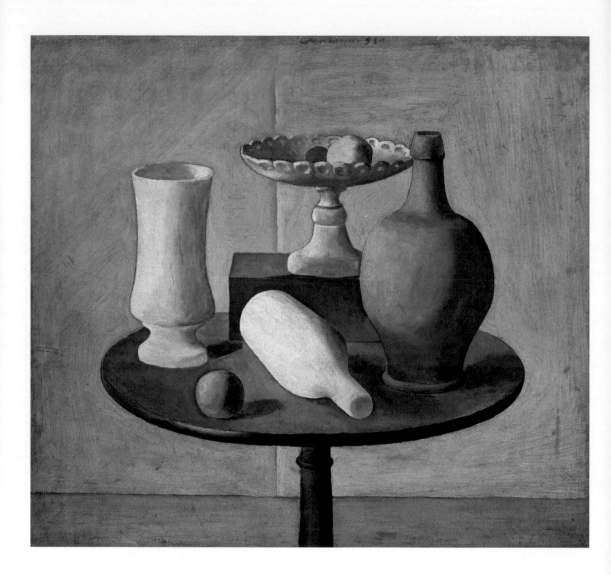

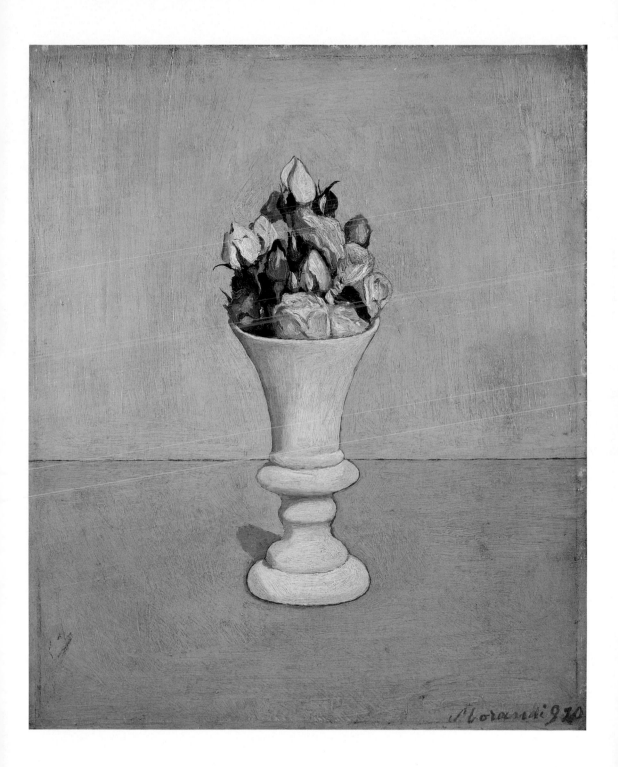

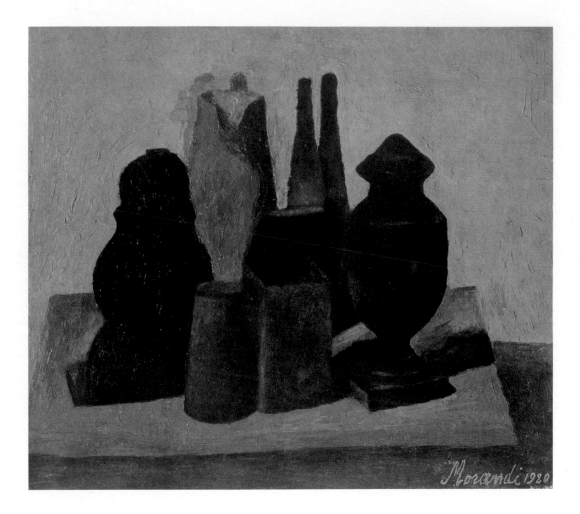

10

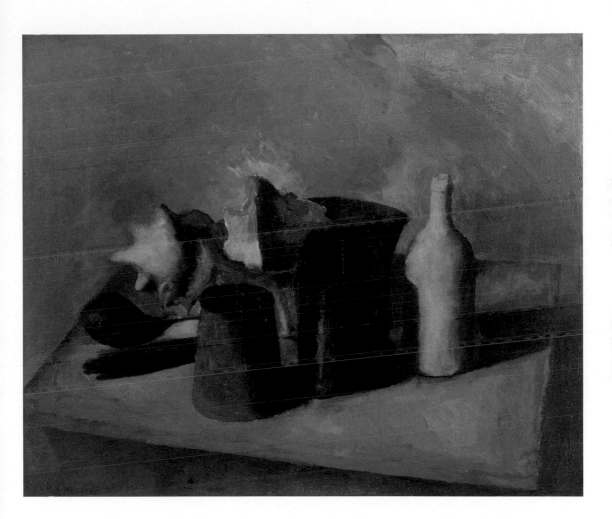

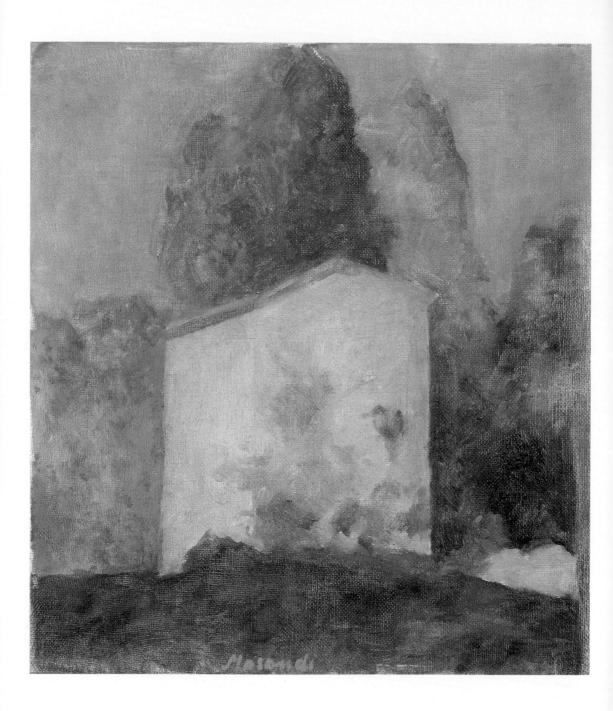

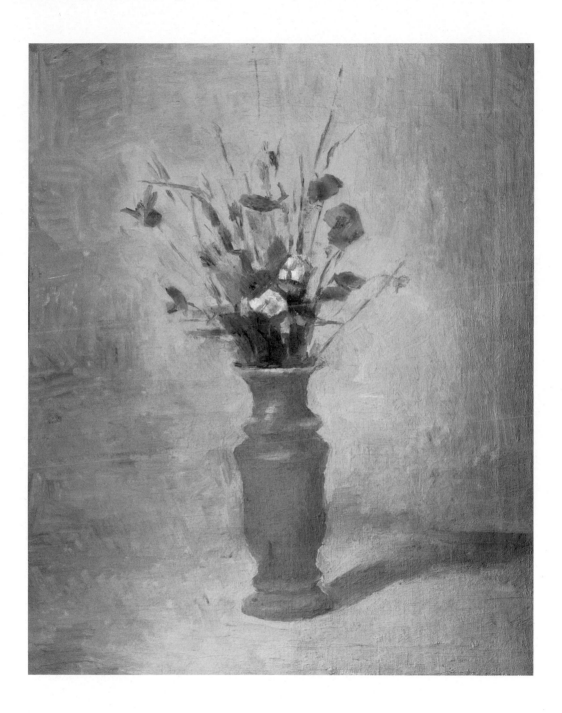

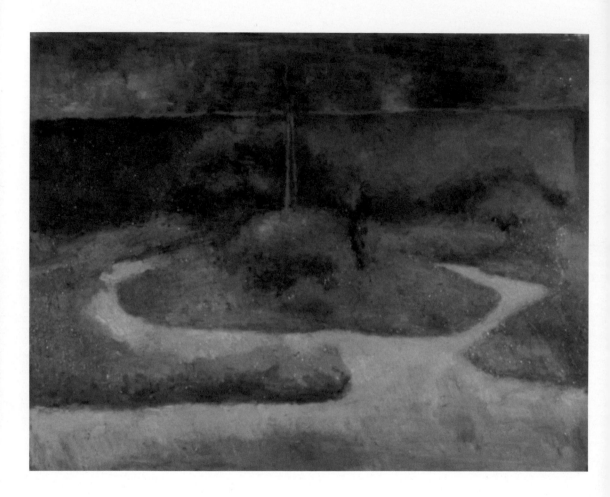

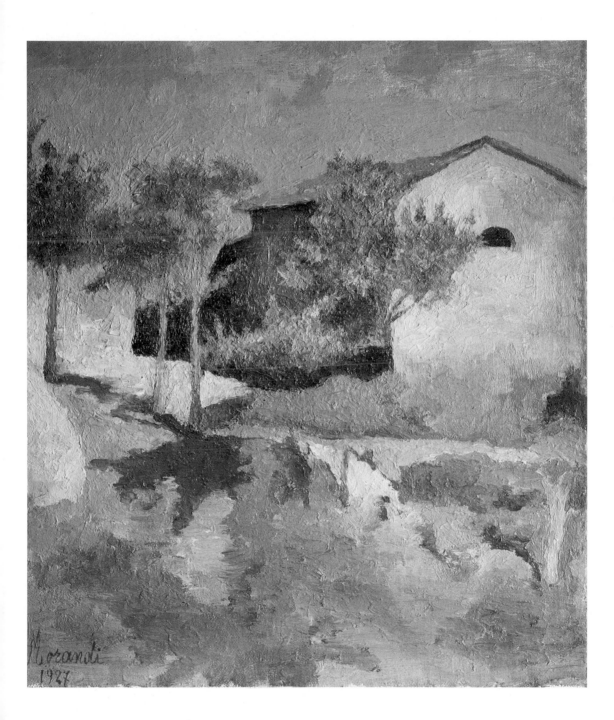

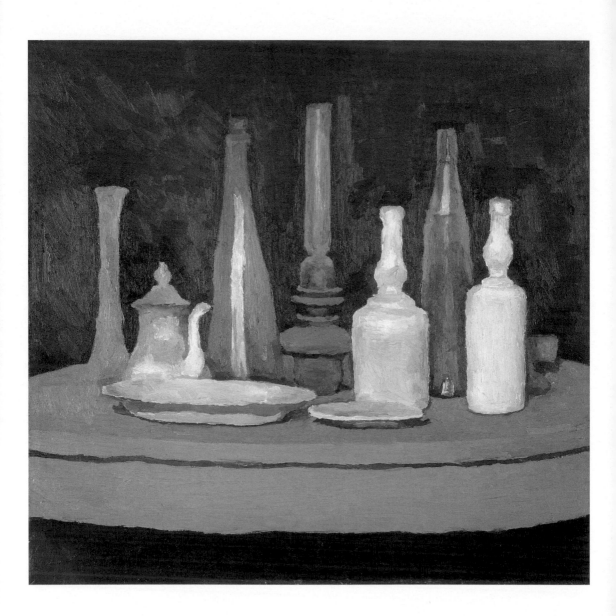

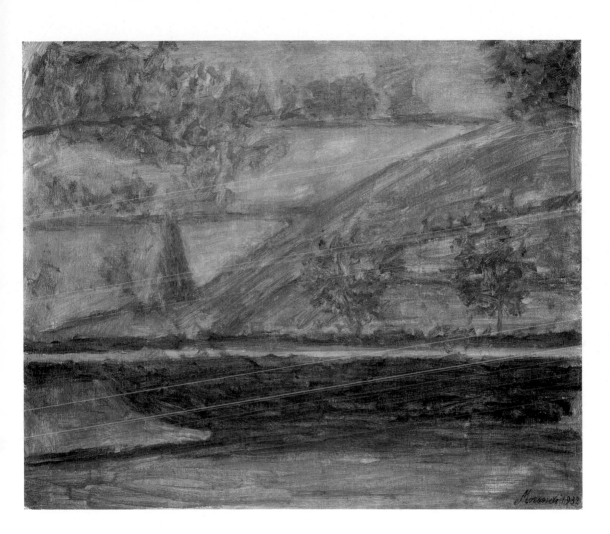

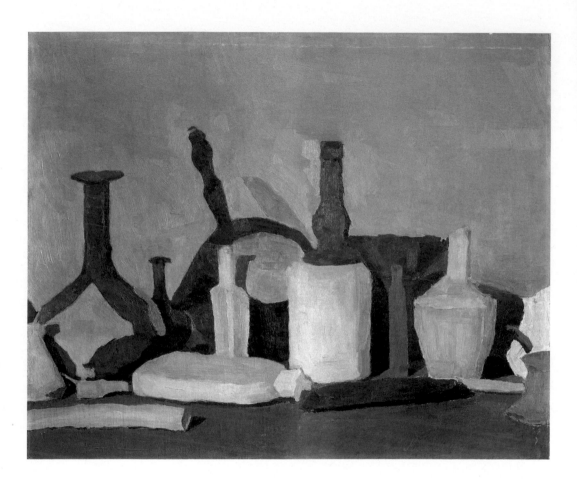

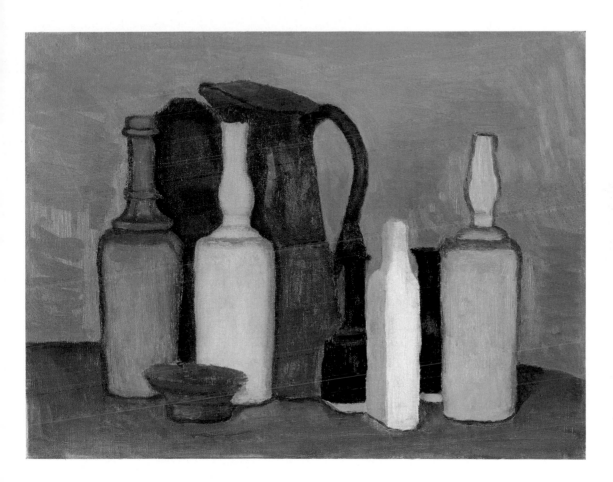

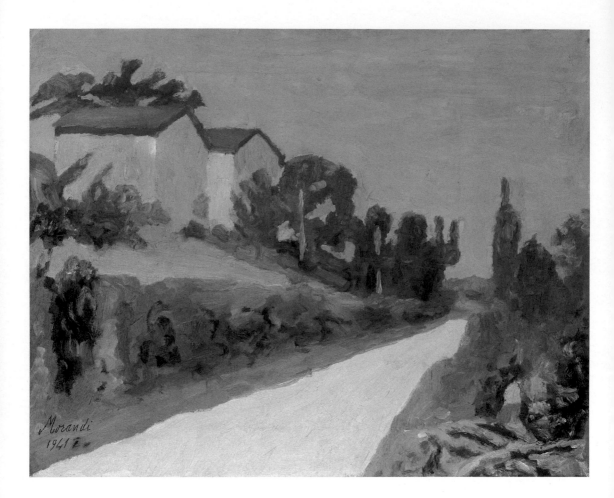

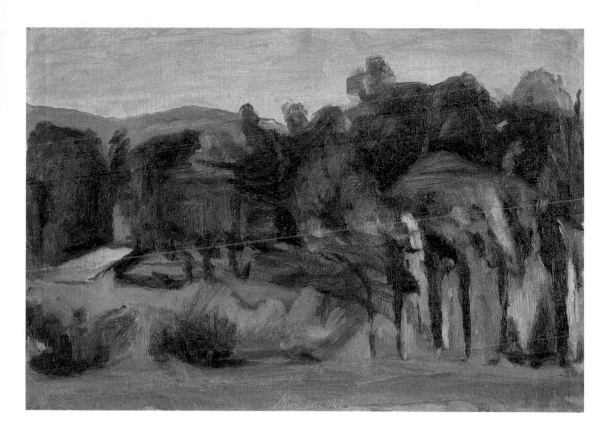

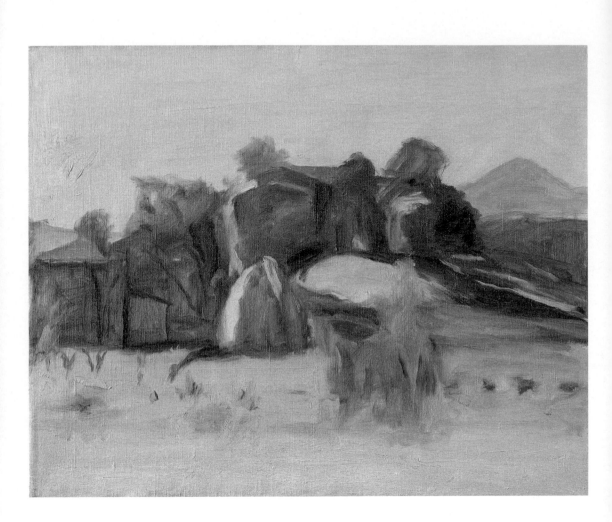

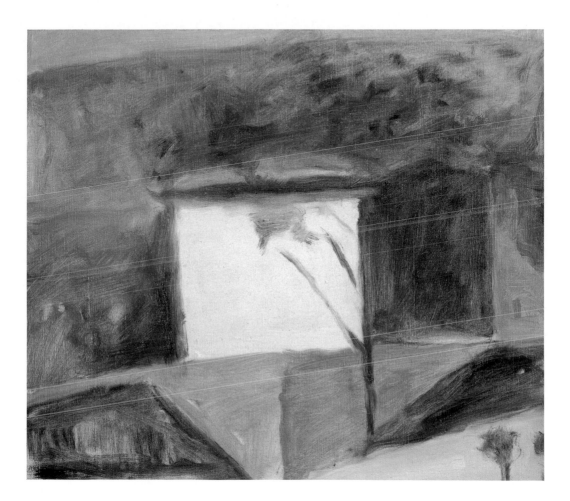

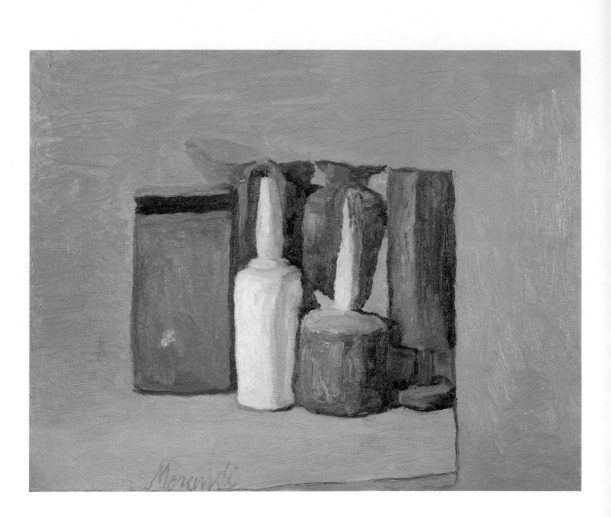

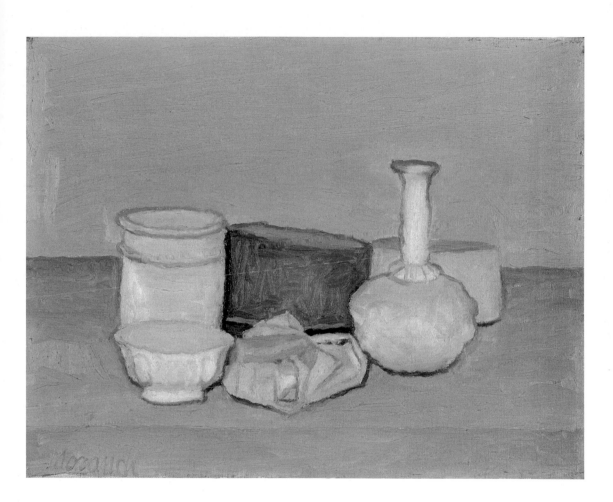

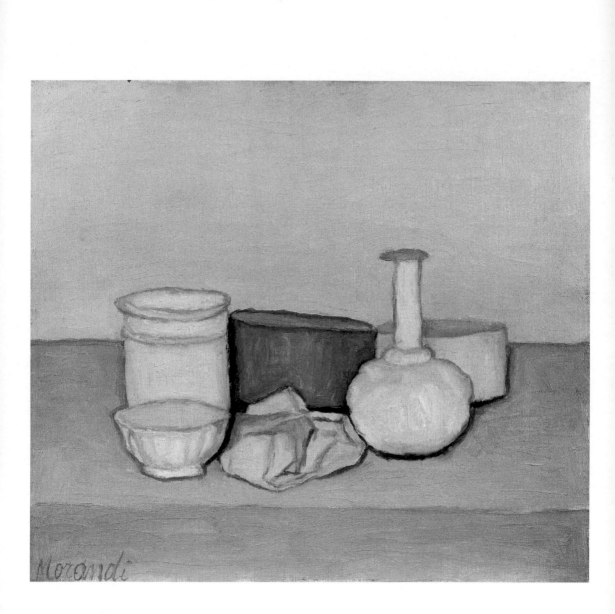

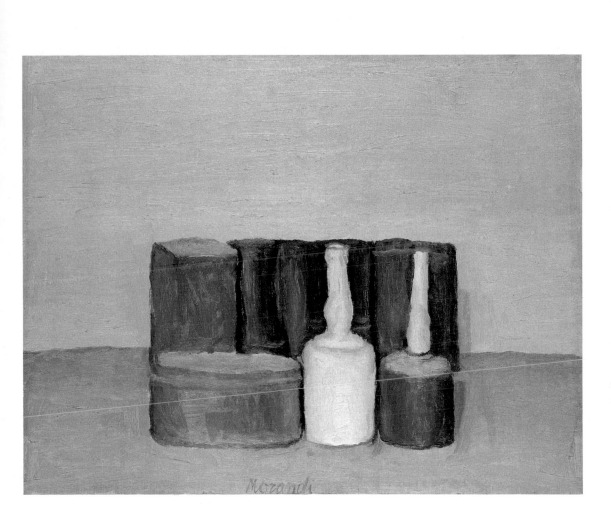

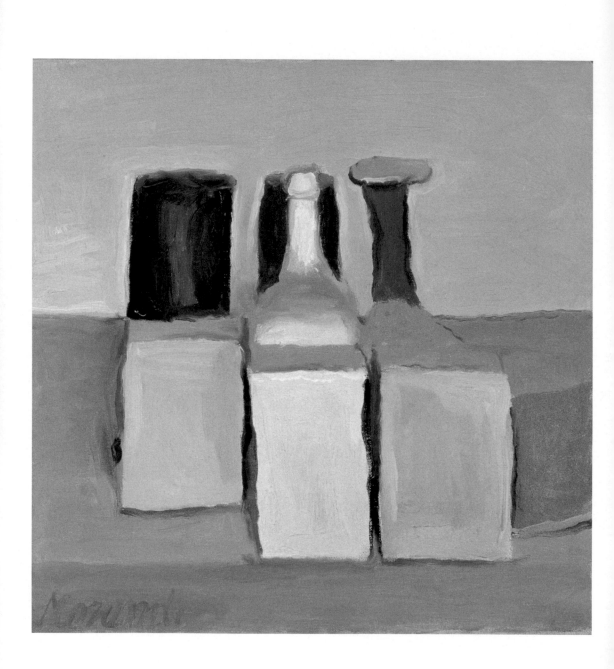

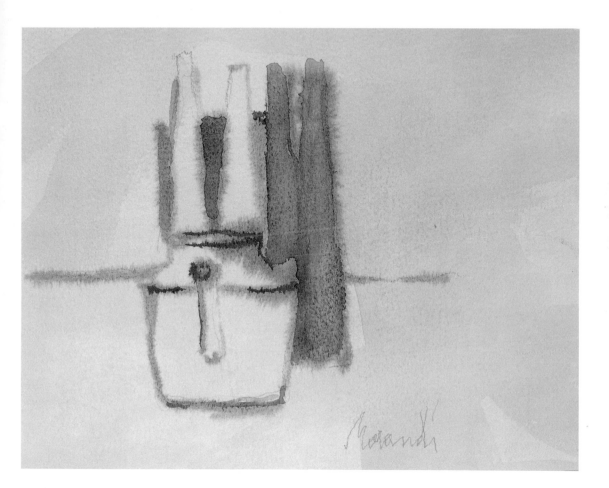

29

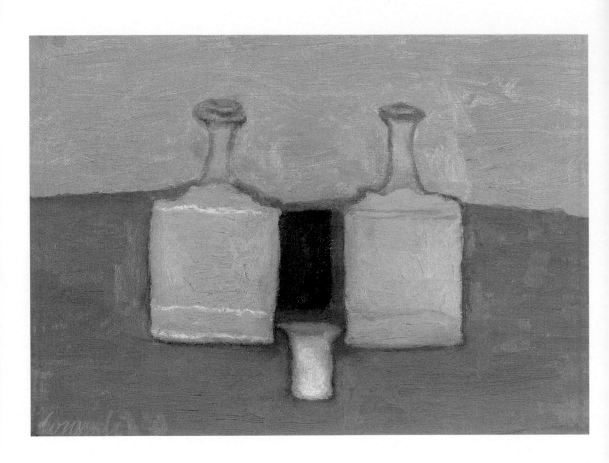

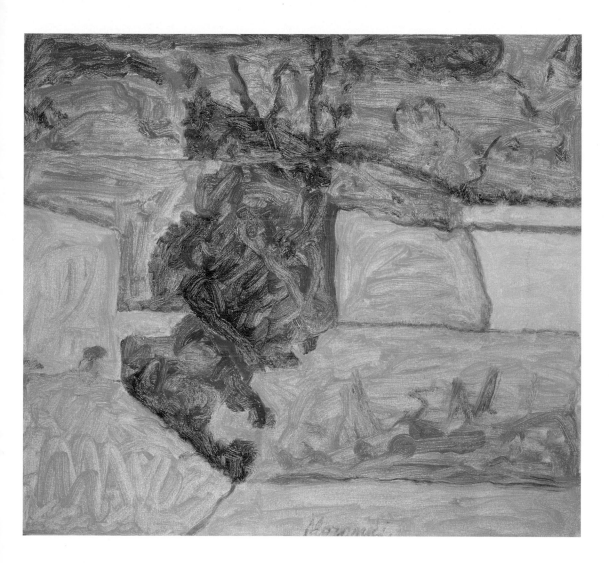

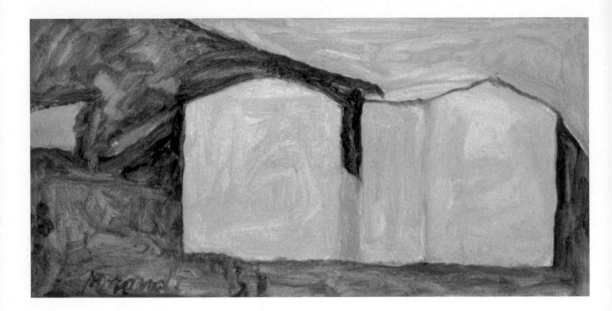

APPENDICES

## 1890

Born in Bologna on 20 July to Andrea and Maria Maccaferri, Giorgio Morandi was the eldest son (a brother died early in life), and his three sisters—Anna, Dina and Maria Teresa—would remain devotedly by his side throughout his life. Two painted terracottas and a small painting of flowers—probably from before 1905, now conserved in the Morandi Museum—are the first hints of a precocious artistic bent. In 1907 he enrolled in the Bologna Academy of Fine Arts where he met Osvaldo Licini and Severo Pozzati, not graduating until 1913. His visual training was already formulated, achieved—with some difficulty in the atmosphere of Bologna at the time, scarcely receptive to modernism—by selectively looking at reproductions (in black and white, as Cesare Brandi will point out) in Pica's book *Gli Impressionisti francesi* (Bergamo, 1908), reading Soffici in the art review *La Voce*, visiting and being thrilled by the Renoir room at the Venice Biennale in 1910. Little travel for Morandi then and in the future: Venice, as we just said; Florence to see Giotto, Masaccio, Paolo Uccello; Rome in 1911 for the 'International Exhibition' where among other things he discovered a few Monets and revisited Renoir.

## 1913

In 1912 he put out his first edition of an etching (the *Bridge over the Savena* whose "Cézannian manner", according to Lamberto Vitali, repeats the style of the 1911 painting Morandi himself acknowledged as his very first, the Jesi *Landscape*). With this limited experience, he faced the world of youthful artistic ardours, first of all Futurist that without ever completely sharing them he did not wish to overlook (especially since even Soffici, who was still his most heeded guide, had made peace with them). So in the spring at Modena then in Florence in December he attended two "Futurist *soirées*". He returned to Florence in January of the next year for the 'Esposizione di Pittura Libera Futurista' organised by *Lacerba* where he discovered works by Boccioni, Carrà,

Severini, Russolo. Soon after in Bologna with Osvaldo Licini and Mario Bacchelli he attended Marinetti's performance *Elettricità* where he met Boccioni and the musician Pratella who asked him to send a piece to Sprovieri for a forthcoming Futurist show in Rome.

In the meantime, on 21 and 22 March 1914, the five artists (Morandi, Licini, Bacchelli, Giacomo Vespignani, and Severo Pozzati) mounted an exhibition at the Hotel Baglioni in Bologna. In turn described as "Futurist" or "Secessionist" (and then later and more accurately by Ragghianti as an expression of neo-primitivism bearing a broad national stamp not lacking in European ties) the show was viewed as a stone cast by a bunch of subversive youths in the quiet waters of the city's cultural scene. Then in Rome he exhibited in the large Futurist show at the Galleria Sprovieri (a "glass" still life and a drawing) and concurrently in the Second Rome Secession (a *Snow Landscape*). This was the last time Morandi would have to do with the Futurist avant-garde; and the last time before his association with Marco Broglio's *Valori Plastici* that he would leave Bologna and his studio seeking those contacts with the world that in his early youth he did not want to miss but would soon deem unnecessary.

## 1915–17

In the fall of 1914 the town council of Bologna engaged him to teach drawing in the elementary schools, a position he retained until 1929; in 1930 after a short period working at the city art high school he was awarded the Chair of etching at the Academy of Fine Arts where he taught until 1956. He was drafted into military service but falling ill he was first put on temporary leave and then discharged. Once again seriously ill in 1917 he worked very little, only exhibiting at an interregional show at Lugo di Romagna (1917).

## 1918–19

Emilio Cecchi came to visit him in Bologna, recalling having seen his *Snow Landscape* in the Secession show. Through Giuseppe Raimondi,

in Rome he met Mario Broglio, director of the *Valori Plastici* review and a painter and dealer as well, with whom Morandi signed his first contract at the end of 1919 (at that time he told Raimondi he had given Broglio seventeen paintings and five drawings). Belonging to the vanguard of the capital's artistic scene, he met De Chirico and Carrà among others and his works appeared in the review on many occasions. At the time his painting received and reformulated Metaphysical influences.

## 1920–22

In 1920 at the Venice Biennale he saw the large room devoted to Cézanne. He resumed etching and kept it up continuously until the mid-1930s. In 1921 he participated in the exhibition Broglio mounted in Berlin (later Dresden, Hanover, Munich) where he showed nineteen paintings along with watercolours and etchings, beside De Chirico, Carrà, Martini, Melli, and others. This was his largest and most important exhibition opportunity, repeated in 1922 at the 'Fiorentina Primaverile' where the "Valori Plastici" group was enlarged and the Morandi room was presented in the catalogue with a page by Giorgio de Chirico: "He looks at things with the eye of the believer, and the intimate skeleton of those things that for us are still lifes, because they are still, appears to him in its most consolatory light: *in its eternal light*. He belongs to the great lyricism created by the latest profound European art: *the metaphysics of the commonest objects*." Furthermore this would be the beginning, precisely out of the ashes of his acceptance of the group's artistic theories, of the greatest period in his painting, henceforth entirely removed from any influence, affinity or model.

## 1923–25

These were "the dark, secret, trembling" years (Arcangeli) of Morandi's first great painting. Now truly locked within Bologna's steadfast walls, according to the cliché imposed by a widespread exegesis often swamped in rhetoric, the painter did not participate, did not take

sides, did not exhibit. At this time but a few had not altogether forgotten him: among them Carrà who in 1925 devoted an article to him in *L'Ambrosiano*.

## 1926–30

In the late twenties Morandi received attention from two different and even opposed fronts: the Novecento and Strapaese movements. To the first the painter sent works punctually and successfully yet with a certain indifference (in the movement's two Italian exhibitions at the Palazzo della Permanente in Milan in 1926 and 1929, and then in the shows Margherita Sarfati mounted abroad: Paris, Basle, Berne, and Buenos Aires).

The case of the Tuscan movement was entirely different. Morandi felt quite close to it, far more than the modest exhibitions his membership in the group brought him, a proximity that at the time influenced the evolution of his painting as well. He published a number of his pictures in *Il Selvaggio*, his work was frequently discussed in Maccari's review and then in *L'Italiano*. He was aware of belonging to a shared sensibility, and even if several constantly repeated critical commonplaces (about a "homey, modest Morandi" and his "straightforward painting, genuine, as homemade as bread and oil", as Leo Longanesi wrote in 1928) probably did not overly appeal to him, it is obvious the Strapaese years for him were a time of "achieved harmony, agreement with the world" (Brandi) and that Morandi regarded Maccari (and again Soffici since he had grown close to *Il Selvaggio*) with the gratitude of someone who, in an Italy that by and large ignored him, felt he had at last found a home and true companionship.

## 1931–38

These were the years of Morandi's new, lasting seclusion. This existential attitude would then cause him to be identified with "the melancholy of things, fondness for solitude, nostalgia for a world of old" (Virgilio Guzzi, 1939) that, if they may never have been the man's, certainly have nothing to do with his painting, not at all

becalmed in a predilection for melancholy and things of the good old days, but instead subjected to endless variations in form, "concealed" to most by the persistence of the few same objects that were merely its pretexts.

After the first great landscape period of the Strapaese years, still life prevailed once again and etching reached its heights toward 1933–34: in a research for a long time so reciprocal with painting that it is difficult to establish hierarchies and precedences between the two. Yet his distance from the Italian scene, more and more caught up in rhetoric, is clear: in the thirties Morandi's exhibitions in his own country were essentially limited to Biennales and Quadriennales (while he declined a number of invitations to exhibit, including the insistent, prestigious one from Libero de Libero to show in the Galleria della Cometa in Rome). Instead Morandi often figured in major Italian art exhibitions abroad, in Europe and the United States, yet he never made up his mind to cross the Italian border to attend one.

### 1939–44

In 1939, in the Third Roman Quadriennale that devoted a huge retrospective to him, Morandi's situation sudden changed and precisely in the context of an exhibition—in many ways minor compared to the great 1935 one—for the first time reflecting the sickening celebrative, rhetorical mood imposed at the time by the regime. After having been a painter appreciated only by an elite and the darling of refined but rare collectors, he became a national figure. Brandi's enthusiastic authoritative critical approval in *Le Arti*, followed by a number of the best Italian critics' expressions of recognition, were essential in this turnabout.

After this success Morandi returned to Bologna, prepared to withdraw again: but something had changed forever. A page by Francesco Arcangeli on the next years gives a fair illustration: "While the nation was tried and vague hopes of freedom began to spread amidst deep anxiety, the

consensus around Morandi, not yet fame and publicity, was warm, genuine, friendly. Those were the years, aside from Brandi's first book, of Raimondi's finest pieces on him: truly for some time Longhi and Raimondi, Brandi and Gnudi, and all of us of the younger generation […] were all united in our veneration for him."

Paradoxically Morandi also owed to that large consensus his being arrested in May 1943 by the Italian police. The only possible explanation was his friendship with men like Ragghianti, Raimondi, Gnudi, Arcangeli, all close to the "Giustizia e Libertà" movement. He was set free a week later owing to Maccari and Roberto Longhi's joint intervention with some Fascist party official. As soon as Morandi was free he sought refuge with his mother and sisters at Grizzana. He usually spent the summer there, this time he stayed on until the end of the summer of 1944, seeking to escape the horrors of the war. Yet they finally caught up with him even there: just before returning to Bologna Morandi saw the first of the decimations that in those mountains would soon turn into a massacre, known under the infamous name of Marzabotto yet that involved the territory of Grizzana as well, its houses and population. In the year he spent there Morandi created some of his most wonderful landscapes (Longhi would tell him the height of his painting); after that he did not return to Grizzana for many years.

### 1945–48

While north of the Apennines the war was not yet over, in April 1945 in liberated Florence the Galleria del Fiore mounted an exhibition in tribute to Morandi, introduced by an essay by Roberto Longhi. After a brief reference to him (unexpected and almost scandalous) in his art history course (*Prolusione al corso di Storia dell'Arte*) at the University of Bologna, whence he had been called to teach in 1934, Longhi had no longer written on Morandi, despite his affection for him. This essay for *Il Fiore* was the first of many in which Longhi's support for the painter became more and more explicit

(in person or publishing in *Paragone* articles on
him by friends or pupils, first of all Arcangeli).
This recognition peaked with the proposal he
made as a member of the ruling commission
and immediately taken up by the general
secretary Rodolfo Pallucchini, to mount the
exhibition 'Three Italian painters from 1910 to
1920' that was to present works by Carrà,
De Chirico and Morandi in the first postwar
Venice Biennale; and later on as a member
of the international jury his intervention for the
Biennale Grand Prize to be awarded to Morandi
(causing De Chirico's wrath). That same year
Carlo Alberti Petrucci mounted a huge etching
retrospective at the Calcografia in Rome: further
recognition of the henceforth universal prestige
of Morandi's work right after the war.

1949–64
Morandi responded to this fame by seeking
seclusion—as he already had in the thirties, and
maybe even more so—in his Bologna studio.
Up to 1956 he kept on teaching at the Academy
where his lessons were as lofty as they were,
perhaps for that very reason, difficult to
assimilate.

He was shown all over the world: in São Paulo,
among other places, in 1953 and 1957 he won
both prizes for etching and painting awarded by
the second and fourth Biennials of the Museum
of Modern Art.

Between 1960 and 1961, first enthusiastically and
then with increasing bitterness because of certain
parts he felt were a misinterpretation, he read
the chapters of a monographic study Arcangeli
showed him as he wrote them—still today the
most complete study—that did not appear until
after his death, published by the Milanese
Galleria del Milione that had handled Morandi's
sales for many years.

Morandi died in Bologna on 18 June 1964.

For a long time Morandi's bibliography was spare, and mostly of little real interest. In the early days of his youth and his maturity, most writings on Morandi were merely episodic expressions of solidarity by his painter friends, such as De Chirico and Carrà, Achille Lega and Maccari, Longanesi and Bartolini, Soffici and Licini; the other sporadic contributions came from journalists, rather than from art critics or historians. Toward the end of this period Roberto Longhi astonished everyone by mentioning Morandi's name at the end of his *Prolusione al corso di Storia dell'arte nella R. Università di Bologna, Momenti della pittura bolognese* (1935), in R. Longhi, *Da Cimabue a Morandi*, edited by G. Contini (Milan: Mondadori, 1973), pp. 191–217: "And in the final analysis, it is no coincidence if even today one of the best painters in Italy, Giorgio Morandi, although navigating through the perilous shoals of modern painting, has nonetheless always been able to steer his course with such meditated slowness and fond studiousness as to seem like a new 'direction' altogether."

Actually, as Longhi himself would recall later on, the "scandal" of having praised Morandi went almost unnoticed at the time. It was not until later that the echo of Morandi's art would suddenly ring out, especially after he was assigned an entire room to himself at the 1939 Rome Quadriennale. His renown then began to spread, amplified by favourable reviews, as of 1948, the year in which Morandi was awarded an important prize at the Venice Biennale, the first to be held since the war. Once the importance of his art was permanently established, (and despite nagging doubts over the exclusively domestic, everyday themes he dealt with), Morandi's critical success continued uninterruptedly, with a sudden proliferation of studies, exhibitions and related reviews at the time of his death in 1964, and particularly in 1966 with the foundation of the Morandi Archives, and subsequently the Museo Morandi in Bologna (1993); further attention came with the centenary of his birth (1990), not to mention the ensuing publications of the general catalogues of etchings, paintings, drawings, and watercolours.

It did not seem feasible here to offer a systematic exhaustive list of such a number of studies. Referring the reader for a more complete bibliography to the catalogue of the *Mostra del Centenario* (Bologna, Galleria Comunale d'Arte Moderna "Giorgio Morandi", 12 May–2 September 1990; catalogue edited by M. Pasquali; Milan: Electa, 1990), and especially to the general bibliography *raisonné* now under way at the Museo Morandi in Bologna. I have chosen to examine key moments of the Morandi exegesis and, instead of following a chronological order within that bibliography, to list the contributions I feel best illustrate the crucial stages in Morandi's life and pictorial research. Since it is impossible to be exhaustive, there will be some fateful omissions, yet the long passages frequently quoted from these sources will hopefully provide some examples of the quality of the interpretation Morandi's work inspired over the years.

But before taking this perforce cursory look at Morandi and the times in which he live and worked, here are a few portraits of the artist himself. Heading the list is Cesare Brandi's short 1942 monographic study: incomparable for timing and interpretative depth, Brandi's study reveals a keen eye for the "form" of Morandi's oeuvre but also a certain intimacy with the man as well, acquired through countless visits to the artist's studio: "In the still lifes the artist's direct role in the scrutiny, arrangement, and make-up of the objects creates a different condition right away. All we need is to watch how Morandi *works* here: starting with his purchases at the Saturday market on the 'Montagnola' in Bologna, and then gradually his systematic selection, rejection, reinstatement of objects amid the accumulation of spent candles and empty bottles. And there," continues Brandi, "he patiently positions them on the plane of the table, whose wooden surface is rendered neutral

with a sheet of paper. Nor is he satisfied with the chromatic nature of the naked glass, porcelain, or celluloid, but in a sort of *prima pittura,* he colours the carafes, coats them inside with a white base, thick and grainy like magnesium, and even adopts the dust layered on them, and finally sees them transfigured in the object itself. For anyone else, this is just an odd masquerade of dirty objects. But in this careful preparation there is already something altogether different from just sitting in the presence of a model" ("Cammino di Morandi" [1942], in C. Brandi, *Morandi.* Rome: Editori Riuniti, 1990, pp. 33–34).

This quotation from Brandi contains in embryo a great deal of the image of Morandi that inept criticism would prosaically dwell on in the future. However, we cannot hope to grasp the first source of Morandi's painting without knowing about these early approaches to his modest "object-constituting" (Brandi). Later, Luigi Magnani, who also knew and subtly read Morandi, wrote in a similar vein: "When Morandi coats a bottle before starting the task (the preparatory stage of a metamorphosis seeking the form of the model, already its reality), thus detaching it from its commonplace reality and conferring on it *something more*, as Rilke would say, by its symbolic investiture, may it not also be a way to turn the eye away from the *thing in itself*, to harmonise it with that pre-established tone, to magnetise it?" (L. Magnani, *Il mio Morandi*; Turin: Einaudi, 1982, pp. 40–41).

Magnani also told about another hidden but very necessary stage of Morandi's gradual approach to painting: "His artistic vocation is always accompanied by a special interest in everything that has to do with the material and the technique of his work; his is a cautious but lively curiosity about the nature of colours, their physicalness and chemical composition verging on the practice of alchemy owing to his almost religious respect for ancient empirical formulas and his faith in their efficiency. One of these practices involved drying a certain blend of colours, and then grinding it together with stone of some kind [...], determined to work like the old masters, with one eye on the mortar and the other on Cennini's prescription book" (Ibidem).

These words echo a famous passage of one of the oldest and most famous of Morandi's witnesses, Giorgio de Chirico. It was in 1922, hardly anyone had written about the Bolognese painter and aside from a friend of his youth, Riccardo Bacchelli, nobody in a national newspaper (*Il Tempo*, 29 March 1918). De Chirico introduced Morandi on the occasion of his first significant presence in a major Italian group exhibition (after Morandi's work had been seen in Germany in the 'Valori Plastici' itinerant shows). And among other things, insisting once again on one of his favourite themes, craftsmanship, he wrote: "So it is with great sympathy and a sweet sense of reassurance that we have recently seen arise, grow and mature with a slow, struggling but firm spirit, artists like Giorgio Morandi. He endeavours to rediscover and create everything on his own: he patiently grinds his colours and prepares the canvas and looks at the objects around him, including the holy loaf of bread, dark and cracked like a secular rock, the limpid form of glasses and bottles. He looks at the group of objects on a table with the same emotion that thrilled the heart of the traveller in old Greece when he looked upon woods and valleys and hills believed to host beautiful astounding goddesses [...] Thus he belongs to the great lyricism created by the last great European art: *the metaphysics of the commonest objects* [...] He is poor because the generosity of the art lovers has ignored him up to now. And in order to pursue his work with purity, in the evening, in the dreary classrooms of a State school he teaches youngsters the everlasting laws of geometric design, the foundation of all great beauty and all profound melancholy" (G. De Chirico, *Giorgio Morandi*, in *La Fiorentina Primaverile*, exhibition catalogue, Florence, Palazzo delle Esposizioni al Parco di Sangallo, Florence 1922, pp. 153–54).

Then the opposite interpretation prevailed: of a Morandi whose metaphysical period, between 1917 and 1919, was viewed as the outcome of a long experimental laboratory rather than an approach, confirming his substantial estrangement from any movement. An assiduous exegete of Morandi's work like Lamberto Vitali who among other things signed the catalogues raisonnés of his etchings and paintings wrote the following in 1966, when introducing the retrospective the Bologna Archiginnasio devoted to him: "We cannot claim he belonged to any of the movements of these past fifty years; certainly not to Futurism even if Morandi exhibited once with the leaders of the group, nor the Strapaese movement of *Il Selvaggio* [...]. And Morandi's so-called Metaphysical period has nothing whatsoever to do with Carrà's, and even less with De Chirico's" (L. Vitali, in *L'Opera di Giorgio Morandi*, exhibition catalogue, Bologna, Palazzo dell'Archiginnasio, 30 October–15 December 1966; Bologna: Edizioni Alfa, 1966, p. 3). Among the many who shared this view was the painter, Renato Guttoso, whose testimony confirms the legend of an entirely isolated Morandi had even overstepped the narrow limits of art criticism: "in fact 'metaphysical art' concerns only De Chirico. [...] Morandi's painting has to do with balance and order, tonal counterweights and correspondences" (R. Guttoso, "De Chirico o della pittura" [1970], in P. Barocchi, *Storia Moderna dell'arte in Italia*, vol. III; Turin: Einaudi, 1992, pp. 363–64). Giuliano Briganti was one of several to agree with this interpretation, yet with far greater critical awareness owing to his familiarity with "metaphysics". In the Bolognese edition of the 'Mostra del Centenario' exhibition, he observed: "Metaphysics for [Morandi] was actually a mere disguise: he used it, out of a sense of the practical, and his unawareness of its kind of mystery, as a mere exercise, undoubtedly extraordinary, of purism and geometry. It was not until 1921 that Morandi found his true expression and identified his own world. A world I do not believe can in the least be defined as De Chirico did in 1922 à 'metaphysics of common objects'" ("Giorgio

Morandi" [1990], in G. Briganti, *Il viaggiatore disincantato*, Turin: Einaudi, 1991, pp. 188–89).

As for Cesare Brandi, in 1942 he had practically given up even using the word "metaphysics" although mentioning the "reconstructed exegesis of volumes" that now appear "in the impenetrable integrity of celestial bodies, so exasperated and icy that the abstract sense of archetypes, as of cylinders, cones, ovoids is lost. They are provoked, not reproduced: their evidence is mental" (C. Brandi, "Cammini", in op. cit, p. 23). Then in 1973 even Brandi would write that "the deserted plazas, the mannequins, the squares, the enchanted rooms would by a reverse motion bring Morandi back to the old painting he would then love all his life, Giotto, Masaccio, Piero della Francesca" (*Giorgio Morandi (1890–1964)*, exhibition catalogue, Rome, Galleria Nazionale d'Arte Moderna, 18 May–22 July 1973; Rome: De Luca, 1973, in C. Brandi, "Morandi", op. cit., pp. 105–11), thereby linking the "metaphysical" period to that of the "Valori Plastici" movement. Arcangeli's position on the subject is more complex and intricate. Above all he means to confirm regarding the metaphysical period what he already claimed about Morandi's earlier years, and to attest that the painter, far from wishing to live in an ivory tower, was close to his own generation in its quest for modernism. Then Arcangeli goes in depth into the different meaning of metaphysics in De Chirico and in Carrà, finally succeeding in defining both the distinctiveness and the limits of Morandi's acceptance of these views. His conclusion is that "I feel excluding Morandi from 'metaphysics' would be a critical mistake [...]. Morandi appears 'metaphysical' in his own way, precisely by that moral and stylistic tension that, although in a declared, concrete objectivity, creates nonetheless a sense of 'magic'." Besides, Arcangeli is aware of the different nature of the approach to the metaphysical mystery and suspension: "In any case Morandi, with his noonday obsession 'comes after' I wouldn't say De Chirico's nocturnes or 'black sun', but also after the short-lived spring lit by Carrà's

pre-dawn or twilight obscurities. Morandi apparently 'normalising' those more romantic attitudes really tends to the limit of the unlikely, splendid sentinel of the purest Italian sentiment, his own capacities, leading to a 'metaphysics' definitely bordering on the 'Ferrarese' one." And last: "Morandi set his teeth, even at the time of his interest in 'metaphysics', not only against De Chirico's northernising sense of the enigma, but also against Carrà's position that 'wavers between north and south'" (F. Arcangeli, *Giorgio Morandi* [1964], 2nd ed., Turin: Einaudi, 1981, pp. 78, 81, 86).

But again Arcangeli's position with respect to Morandi's period of "metaphysics" and then *valori plastici* (plastic values) stemmed particularly from his need to be consistent with what he had been the first to sense and develop in the first part of his monographic study: that Morandi, aside from being "unknown" as Bacchelli had lucidly confessed in 1918, was at the heart of his times at least in the limits of a loftily provincial cultural situation such as that of Bologna. "And if for painting", Arcangeli then wrote, "his peers in their twenties were Matisse, Derain, Utrillo, and Soffici, Morandi was accompanied in his arduous, lonely conception of art by the "minority culture" expressed in *La Voce*. We shall never be able to claim Morandi ever saw himself in any form of activism; yet nor can we deny his mute, concrete, even if remote consonance with what was, or tried to be, open-mindedly serious and modern" (F. Arcangeli, *Giorgio Morandi*, op. cit. p. 7).

Both Brandi and Arcangeli consider the end of 1920 and the beginning of 1921 key moments for the birth of the great Morandi. On several occasions they wrote wonderfully intense pages (the younger one "following", approving, challenging the older scholar, but never ignoring him: in a close dialogue from afar that remains one of the most important, fascinating moments in the history of twentieth-century Italian criticism). Brandi: "Out of the dull, subtracted colour range denser if not brighter tones

blossom. But how gradual it is: as though grown out of an intimate consequent enrichment. Volumes remain isolated and present, with their adhering surfaces, a decisive rhythmic moment: they are, so to say, the *arsis* sustaining the rhythm and succession of voids, no less *measured*, no less *capable* than the solids [...] The atmosphere is as though numbed, all the objects as though dipped in plaster, misted over by human contacts". And Arcangeli replies, just before quoting Brandi from the passage we just mentioned: "henceforth the *valori plastici* are gone. Surfaces are misted over by a veil of feelings still difficult to confess, yet present in the subtle apprehensive gentleness diffused throughout; and shadows are back, no longer tidy evidence of imperious volumes, but modest, tender, obsequious servants of the bodies" (C. Brandi, "Cammino", in op. cit., p. 26; F. Arcangeli, *Giorgio Morandi*, op. cit., p. 107).

We shall quote Brandi again in a crucial passage on etching showing that in the twenties it was equal to painting and at times maybe even its "teacher": "Aside from the manual aspect of their different techniques, Morandi's etchings are not at all distinct from his pictorial conception. Their reciprocity is so great that in the hatching corrections of the prints we can observe the same thing as the overlaying of brushstrokes. And even where the pure white of the paper surfaces [...], its value as a chromatic surface, redeemed from a narrow chiaroscuro task, asserts its pictorial origin beyond any doubt. This persisting unequivocal chromatic fact [...] explains the value, never exclusively linear, of the outlines, and we understand, as in the admirable drawings, the meaning of the line's characteristic fluctuating whereby the formal concreteness is never undermined nor weakened. Instead it is precisely those chipped, trembling outlines that allow us to verify how little the artist, in building the volume, trusts the line's plastic summary, demanding of it a *variation* similar to the chromatic and light variation of the raised layer of colour". Freshly "trained by etching", Morandi conveys his new formal acquisitions to painting: "where his increasingly refined

awareness of colour, in the endless combinations of a given colour with light, not only sees rich variations in tone but also discovers related plastic implications, the autogenous spatial graduation" (C. Brandi, "Cammino", in op. cit., pp. 28–29). Brandi thus indicates in very clear words and concept what he would call "positional colour". He calls it that and not just "tone" because it achieves and determines not only the slightly varied gradient of the individual chromatic area but thereby the spatial position of the object to which it belongs.

Then Arcangeli is the author of several unforgettable interpretations of the pivotal works of these years. Just one example, relative to the Jesi *Still Life* that concludes the year 1920: "Therein surfaces, like a secret, inalienable quantity (we shall often see it again in Morandi) a 'metaphysics' henceforth entirely repressed within the darkness of a tone like a full, extreme twilight, intuited by eyes that are now close to night-time […]. What are these members of a mysterious family assembled for? For defence, for witchcraft? Everything is disturbing: that raised lid; that form on the right of the vase hooded like a Tibetan; the profile of the clock already so often painted but now brown, dense, crouching like someone kneeling; even the two long bottles raised over it all like conspiring towers of old Bologna. And it is singular that this dramatic atmosphere cohabits with the first of his compositions in the Latin etymological sense: several objects, indeed seven, placed together forming a whole" (F. Arcangeli, *Giorgio Morandi*, op. cit. p. 108).

The two historians then agree in acknowledging that in 1925 he reached "a time of an agreement, a harmony with the world" (C. Brandi, *Cammino*, op. cit. p. 27), right after the early twenties, after those "dark, secret, trembling years, among the greatest in Morandi's art" (F. Arcangeli, *Giorgio Morandi*, op. cit., p. 121). Instead Arcangeli disagrees with Brandi's view that deems the period relative to Strapaese (from 1925 through 1928) as "one of the highest moments of all his

painting": Arcangeli replies, reasonably, that "at that time there may have been a stagnation", at that time in which "shunning especially the rhetorics that had begun to take over twentieth-century painting […], it is natural that a man who shares and will share all his life the modest, dignified condition of a family would feel the attraction of Strapaese: *Il Selvaggio* and *L'Italiano*, Longanesi and Maccari would be his reference for years"; so that sometimes Morandi's art would reflect "a pathetic but intense nineteenth-century flavour" (ivi, pp. 152–53, 159).

It would be worthwhile closely following this dialogue between the two critics, a true and fruitful exchange since at least for a while Arcangeli could even get Brandi's attention. Through them and their voices, rendered clear and more enlightened than others by their excellent writing, we could follow Morandi's career during the thirties up to the Quadriennale and then the war, but our limited space prevents it. So we shall briefly turn back to the reviews of those years, while referring for a broader panorama to the documented synthesis Marilena Pasquali offered in her essay in the catalogue of the Morandi exhibition "Morandi e il suo tempo" held in the Galleria Comunale of Bologna in 1985 ("'Quelle sabbie portate a vibrare…' La trasformazione dell'immagine morandiana tra il 1925 e il 1939", in *Morandi e il suo tempo*, Milan: Mazzotta, 1985, pp. 54–68). In the midst of these years we should at least mention Vitali's words. Far from being as obvious as they may seem today they are meant to correct the increasingly ironic remarks "on the bottles and jugs that insistently return in our friend's paintings and etchings", and for the first time seek to explain that "as for every artist worthy of that name, for Morandi the subject is only a starting point and not the end, in other words is the necessary stimulus for transfiguration" (L. Vitali, *L'incisione italiana moderna*, Milan: Hoepli, 1934, p. 63). And we should especially recall that besides, throughout the thirties, the truest support for Morandi came from the small but elect circle of his collectors—Roman and

in particular Milanese (Feroldi, Valdameri, Cardazzo, Della Ragione, Mattioli, Jesi, Jucker, Giovanardi, among others)—and the galleries that followed his work (il Milione, Barbaroux, la Cometa, la Galleria di Roma).

The dedicated room at the 1939 Rome Quadriennale led to a new, decisive critical interest in Morandi. For the first time, Marchiori, Apollonio, Morosini, De Libero, Guzzi and many others fully perceived the painter's stature. At the same time the first monograph appeared, by Arnaldo Beccaria (*Giorgio Morandi*, Milan: Hoepli, 1939), and especially Brandi's first long piece ("Cammino di Morandi", in *Le Arti*, 3, 1939, pp. 245–55) that would soon come out in book form (*Morandi*, Florence: Le Monnier, 1942). Compared to these favourable reviews, the negative ones by Carlo Belli were of scarce account (twice in the Ferrara *Corriere Padano* in 1939 and 1940) as well as the ones by his old companion of *Il Selvaggio*, Luigi Bartolini: "And, dear Morandi, frankly [...] I don't care for these sincere modest little lights of yore, painted to study tones and forms, academicising them, and now become a living-room genre" (L. Bartolini, "Un pittore fra i pittori della Quadriennale", in *Quadrivio*, 12 February 1929). And we would not even remember this outburst of Bartolini, a great etcher with a foul character, if it were not a sinister harbinger, in the midst of the Fascist period, with its implicit accusation of "hermeticism" and explicit one of "academic", of all the incomprehension Morandi would run into on behalf of the militant left in the postwar era that we had hoped would be entirely renovated for figurative art as well.

Occasionally at the time, some criticism strengthened by old and new enthusiasts, brought significant contributions to Morandi's painting (see for instance the two monographic studies by Giuseppe Marchiori, *Giorgio Morandi*, Genoa: Editrice Ligure Arte e Lettere, 1945; and by Cesare Gnudi, *Morandi*, Florence: Edizioni U, 1946). Opportunely recording its new tendencies as his old friend Giuseppe Raimondi did in

*L'Immagine*, the review that Brandi edited, in which Morandi's name and work were almost at home: "In the compositions the thickness of the dreamy dust, the milky light, an anxiety in the vision are ebbing. The objects alone have become *firmer* as though seized in a light of happiness. It is a lull, like in the sky; a day in a season that will never return. From the summer of 1946 until today this super-human (or inhuman) state shows no signs of yielding. It gives us an indescribable sense of wonderment. An unfamiliar word is uttered: grace" ("Morandi 'dopo-la-liberazione'", *L'Immagine*, 3, 1947, pp. 176–78). But Morandi also had to hear other rude, coarse voices censuring his isolation and absence of commitment, "using him" for the benefit of a mistaken battle. "Every room of Morandi's reminds us of those painters who never met anyone in all their life and saw the lives of other men and things through their window pane. Morandi is a painter for chilly, reclusive intellectuals; he is the image on the wall to whom one turns in times of affliction; he is the little god of critics who do not want to observe and serve [...]. That is why Morandi is a painter who will always appeal to intellectuals and whom workers will never understand, neither now nor ever" (R. De Grada, "Cronache d'arte. Un pittore puro", in *L'Unità*, 5 January 1950).

The most innovative voice (and subversive compared to those preceding) during the fifties is undoubtedly that of Carlo Ludovico Ragghianti. He "upset the intimist-tonal interpretation still widespread in reviews on Morandi and made the painter [...] a clear-minded spatial architect" (F. Fergonzi, "Catalogo delle opere", in *Morandi ultimo*, exhibition catalogue edited by L. Mattioli Rossi, Verona, Galleria dello Scudo, 14 December 1997–28 February 1998; Milan: Mazzotta, 1997, p. 126). Ragghianti wrote that "they are not rhythms and tones and atmosphere, or rather they *are* all this, but in an organisation of an artistic image that can be ideally reconstructed in a plan [...] and various elevations and horizontal and oblique vertical sections in a synthesis that, once it is critically taken apart, offers the viewer the

huge capacity of a construction that, as I was saying, is so entirely architectural that we should speak of *cathedrals* rather than bottles" (in *Morandi ultimo*, op. cit., ibidem). So the parallel with Mondrian, later explicitly expressed by Ragghianti, was just around the corner (C. L. Ragghianti, *Arte moderna in una raccolta italiana*, exhibition catalogue, Florence, Palazzo Strozzi, April–May 1953, Milan: Edizioni del Milione, 1953; Ragghianti would write about Morandi several times in that period).

Morandi's exegesis, up to his death, would not be further subjected to any so abrupt a "trauma" (a beneficial trauma, even if not entirely shareable nor was it shared by everyone, least of all by Morandi). It did receive confirmations and new input, soon also testifying to the vast interest in his painting that had arisen abroad.

After his death, and especially the 1980s, quantities of new studies on Morandi appeared. The essential ones include: *Morandi e il suo tempo*, the first proceedings of the seminar held in Bologna in November 1984 (Milan: Mazzotta, 1985), then come the catalogue of the homonymous exhibition mounted in the Galleria Comunale d'Arte Moderna of Bologna the following year (9 November 1985–10 February 1986; Milan: Mazzotta, 1985); or the countless retrospectives mounted abroad first by the Archives then the Museo Morandi with its excellent *Catalogo* (Milan: Charta, 1993) edited by Marilena Pasquali, who for years was the effective director of those institutions. Later on she was frequently responsible for publishing his correspondence, highly significant in a life spent almost entirely inside the walls of Bologna (for example in *Giorgio Morandi. L'immagine dell'assenza*, Grizzana Morandi, Sala Municipale Mostre, 22 July–2 October 1994; exhibition catalogue edited by Marilena Pasquali, Milan: Charta, 1994). Rather than examine in detail any of these notable more recent studies, it is worth looking at the very first recognition of Morandi's greatness after his death (even before the tribute paid him by his own city, Bologna, with the

October 1966 Archiginnasio retrospective curated by Roberto Longhi, Gian Alberto Dell'Acqua, and Lamberto Vitali), which took place at the Venice Biennale, Italy's most important venue for contemporary art. The special exhibition that Venice devoted to him in 1966 included over eighty easel paintings covering the period 1911 to 1963; ten watercolours, and fifty-five etchings, presented with Roberto Longhi's ground-breaking essay of 1945. In the catalogue (*Catalogo della XXXIII Esposizione Biennale Internazionale d'Arte*, Venice: Ente autonomo "La Biennale di Venezia", 1966, pp. 22–26) the essay is preceded by a brief commentary that offers two striking points worth mentioning. After first mentioning their being practically of the same generation, Longhi proceeds with great feeling, ("a mere few months difference, we belonged to the same generation") and notes that he "saw him reach the acme of his 1943 landscapes, perhaps his greatest achievement". Then he continues with a severe reprimand to Arcangeli (who is not named, but one can read between the lines) and his recent monographic study, which he (and, as far as he understood, also Morandi) felt had too explicitly shown Morandi as a forerunner of the informal trend prevailing at the time: "On rereading this brief essay" (i.e., the introduction for the Galleria del Fiore in Florence, which was reprinted in the Biennale catalogue after Longhi's main essay) "I would like to think it may still serve as an introduction for today's public, and also to ransom Morandi from a context that circumstance placed him in, and about which he can unfortunately no longer enlighten us, other than through the works themselves."

[2] Fabrizio D'Amico (Rome, 1950) published essays and books on Mannerist and Baroque painting and on nineteenth- and twentieth-century Italian and European art. He mounted exhibitions on Monet, Mafai, Raffaello, Pirandello, Ferrazzi, Hartung, Afro, Turcato, Scialoja, Melotti, Pascali, Bendini, Perilli, Mattiacci, among others.He holds the chair of History of Contemporary Art at the University of Pisa. Since 1976 he collaborates in the cultural pages of the daily *La Repubblica*, as editor of the contemporary art section.